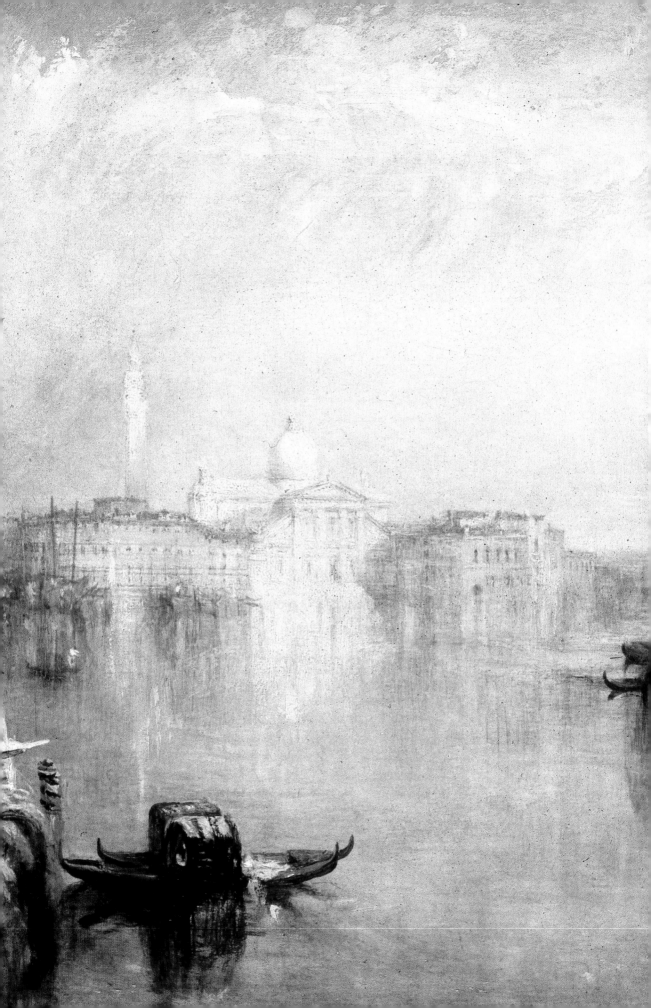

Inge Herold

TURNER
on Tour

Prestel

Munich · Berlin · London · New York

Contents

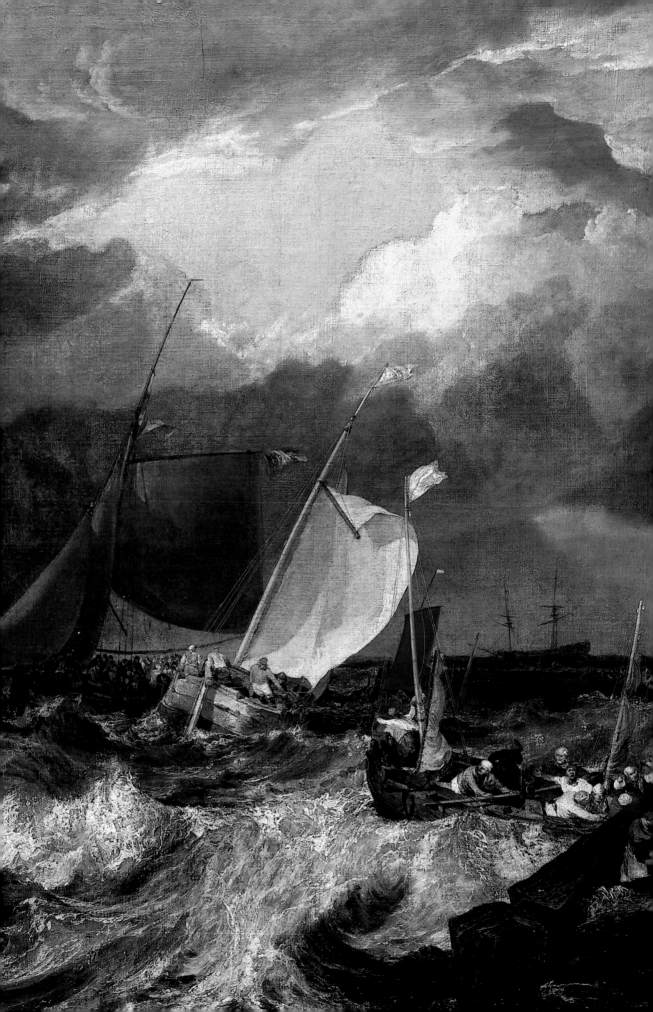

Turner on tour

"Don't accuse me of Anglomania, dear reader, if I very frequently mention
the English in this book; they are now too numerous in Italy to be over
looked, they traverse the country in huge swarms, camp in all the inns, run
around all over the place in order to see everything … When you see those
fair, red-cheeked people with their shiny carriages, colourful lackeys,
neighing horses, chambermaids and other precious belongings, inquisitive
and clean, crossing the Alps and wandering through Italy, you feel you
have experienced an elegant mass migration."[1] With these ironic senten-
ces in his Reisebilder (Pictures of Travel), which appeared between 1826
and 1831, Heinrich Heine passed comment on a phenomenon of his time –
the British enthusiasm for travel. Johann Wolfgang von Goethe, too,
could not resist a remark on this topic when he makes Mephisto say to
Faust on Walpurgis Night:
"Say, are there any Britons here?
They're always roaming far and near,

*Detail of
illustration
on page 9*

7

To spy out battle fields, old crumbling walls,
Drear spots of classic fame, rocks, waterfalls... ."[2]

Goethe himself had lived in Italy from 1786 to 1788 and immortalized his impressions in the famous Italienische Reise (Italian Journey). Heine was in Italy in 1828 and might have met the British painter William Turner, who set out for Rome that year. Like his fellow countrymen, Turner was a passionate traveler, even if he was never able to journey under the luxurious conditions described by Heine. All his life, travel – the encounter with unfamiliar landscapes, cities and people – was for him an indispensable stimulus for his art.[3] His fellow artists Clarkson Stanfield, Samuel Prout, John Sell Cotman, David Roberts, William Havell, Richard Parkes Bonington and Thomas Shotter Boys also made journeys on the Continent, but none of them felt the impulse to go abroad as frequently or as regularly as Turner.[4] Eloquent testimony to this are the sketchbooks filled on his journeys, the innumerable studies, watercolors and oil paintings.

Over the last few years, Turner's travels have increasingly formed the focus of research. In many cases researchers have succeeded in reconstructing his tours in more detail, occasionally even redating them. Previously unidentified subjects have been matched to a location, and connections to his overall oeuvre have been established.[5]

The passion for travel that reached its first high point in the 18th century was accompanied by travel diaries and literary travel memoirs of the most diverse type. A publication by Lord Byron (1788–1824) had the greatest impact; he incorporated his own experiences from journeys that had taken him to Spain, Germany, Italy, Greece and even to the Orient into the verse epic 'Childe Harold's Pilgrimage'(1812–1818).[6] The autobiographical figure of Harold, which made Byron famous overnight, caught the feel of an entire era: restless, torn, melancholy, simultaneously passionate and ironic, Harold is a typical child of his time, marked by the experiences of the Napoleonic age. Not intended to be a guidebook either in its artistic form nor by the poet, the epic nevertheless soon acquired the function and effect of one. Shoals of Byron's enthusiastic readers followed in the footsteps of the eponymous hero, including Turner, who frequently took his direction from Harold's goals and sometimes added quotes from the poem to his pictures. His involvement with the poet's works finally peaked in the 1830s, when he prepared vignettes for the publication of Byron's Life and Works by the British publisher John Murray.[7]

Calais Pier, with French Poissards Preparing for Sea:
an English Packet Arriving, R.A. 1803

At the same time, in order to meet the demands of the ever greater number of travelers, practical guidebooks rooted in the more prosaic travel descriptions of the Enlightenment were developed, taking as their model in the first half of the 19th century John Murray's "Handbooks for Travellers" – still the perfect example today. As we will see, Turner himself often turned to the latest guidebooks to prepare for his tours and followed the routes they recommended.

A further genre that developed as a direct result of the enthusiasm for travel that had been steadily on the increase since the 18th century was that of topographical engravings. These tempted people to visit far-off

places, acted as sources of information for the journey, as mementos of what had happened and been experienced, or even functioned as a substitute for a journey. Thus even in the 18th century, especially in England, there was a market for series of engravings and illustrated travel guides that increased massively in the first half of the 19th century. Turner, too, profited from this as a popular supplier of designs for engravings.

These developments must be seen as evidence of a new era in travel. The Napoleonic Wars had put a stop to the traditional Grand Tour for the time being. The British, in particular, as a result of the political situation – Napoleon had pronounced a continental blockade against England in 1806 – found it impossible for a long time to travel freely in continental Europe. And when it did become possible again following Napoleon's defeat in 1815, a new era had begun not only in the political, economic and social spheres but also with regard to travel. Technological achievements had made much greater mobility possible, which soon led to a form of mass tourism. This development was essentially started in England, but was based to a considerable extent on improvements in transport and roads carried out by Napoleon in the course of his military campaigns. Both the first coaching roads over the Alps and the Route Napoleon along the west bank of the Rhine, as well as the installation of regular stagecoach services, stem from the French conqueror.

The first steamboat on the Rhine in 1816 went from London via Rotterdam and up as far as Cologne. The four days that the steamer took were a sensation by comparison with the six weeks that were normally needed for the journey using horse-drawn boats. Eleven years later the Prussian-Rhenish Steamship Company started a regular service on the stretch between Cologne and Mainz; Turner often used this speedy connection for his later journeys. The railway too was a technological innovation developed in England that made traveling vastly easier. The idea of the organized package tour was also born in England: Thomas Cook founded the first travel agency in 1845, initially offering trips within England, then adding tours of the Continent from 1855.

William Turner's journeys should be seen against the background of these changes. The beginning of his career coincided with the end of the elitist Grand Tour, and when he died in 1851 people were already complaining about the effects of mass tourism along the Rhine. His period of artistic activity began with the outbreak of the French Revolution and ended in the year that England presented itself at the World Exhibition as a leading in-

Our landing at Calais. Nearly swampt,
Calais Pier sketchbook, 1802

dustrial and international power. Thus, Turner's painting developed within
the field of tension between the traditional and the modern.

Turner began his artistic career as a topographical draftsman. Even
before he became a member of the Royal Academy in 1802 – the country's
most important artistic institution, founded in 1768, where he would exhi-
bit his pictures almost every year – he had made a name for himself as a
supplier of designs for the series of topographical engravings that had be-
come fashionable, and he had found influential patrons and buyers for his
landscape watercolors. The basic pattern of his artistic production had be-
come established quite early on. During the summer months he went on
lengthy journeys, initially within the British Isles, filling his sketchbooks
with innumerable pencil studies. He would assess this material once he
was back in his studio, using it to produce color studies, worked-up water-
colors intended for sale, or ambitious, large-format oil paintings. He very
rapidly moved from pure topographical illustration[8] to landscapes full of
atmosphere with a symbolic content which revealed his artistic goals, his
striving for landscape painting to be reassessed. Turner's depiction of
landscape, an his view of nature found their models in the work of artists –
Nicolas Poussin (1594–1665), Salvator Rosa (1615–1673) and Claude Lor-
rain (1600–1682) – whom he admired and who had broken down the bar-
riers between the genres of landscape and historical painting in favour of
the 'historical landscape'. In addition, Turner owed a great deal to his fel-

low countrymen John Robert Cozens (1752–1797) and Richard Wilson (1714–1782) and their concept of landscape imbued with feeling.

A publication by the politician and philosopher Edmund Burke (1729–1797)[9] proved highly influential on contemporary esthetics with regard to the depiction of nature and its perception, and this too affected Turner. In his tract *A Philosophical Enquiry into the Origin of our Ideas of the Sublime and the Beautiful*, which appeared in 1757, Burke postulated that landscape painting should be aimed at the infinite, the overwhelming, the heroic – at nature that aroused awe and terror in human beings. In contrast to the Beautiful, which – embodied in the smooth, small and symmetrical – arouses pleasure and joy, the Sublime should therefore be directed towards the esthetic experience of nature that is felt to be a threat, in the shape of tempestuous seas, vertiginous cliffs and extreme weather conditions. Delight in limitless nature was accompanied by a feeling of terror, with a predilection for depiction of catastrophes of all kinds, as is also characteristic of Turner's work.

At the end of the 18th century the engraver and writer William Gilpin (1724–1804) introduced a further term into the discussion of esthetics. In three essays published in 1792, 'On Picturesque Beauty', 'On Picturesque Travel' and 'On Sketching Landscape', he developed a momentous theory of travel that had a decisive influence not only on the way in which landscape was experienced but also on its depiction.[10] A flood of 'picturesque views' followed. Gilpin found picturesque beauty in high cliffs, in ruins and remains of medieval architecture, and in the course of great rivers. Views should be varied, nature should be enriched by culture shaped by human hand, and man should appear as a staffage figure. Gilpin was not concerned with topographical accuracy but with awakening associations and atmosphere. As a result of Gilpin's 'catalog', the eye of the tourist – like that of the artist – was directed to specific attractions and landscape elements, so that over the course of time a unifying 'eye', a standard canon of perceptive and illustrative patterns, developed. Turner adopted this too, but – as a consequence of his wealth of invention, his mastery of color and his command of technique – he knew how to enliven and vary it.

But let us go back to Turner's travels. In his first productive years, the 1790s, he traveled systematically throughout his native land, partly as the result of political events on the Continent. He visited southern and northern England, the Midlands, Wales and Scotland. In April 1799 he refused an offer from Lord Elgin to accompany the latter to Athens as a topogra-

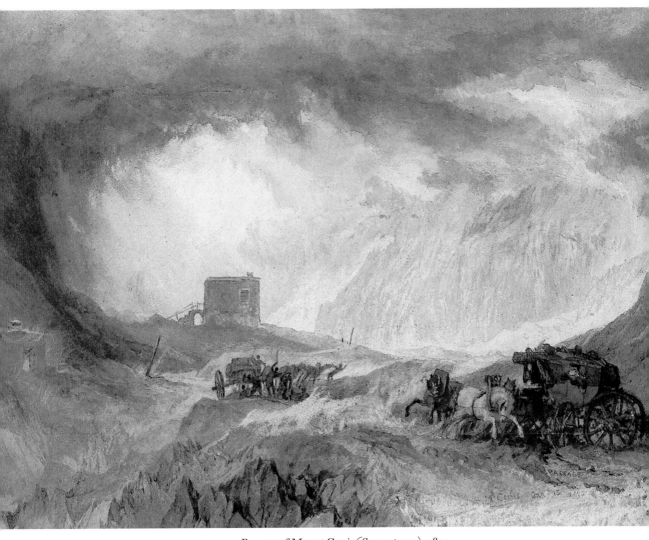

Passage of Mount Cenis (Snowstorm), 1820

phical draftsman. Whether the true reason for this refusal was the excessively low pay, a disinclination to have his artistic freedom restricted in the service of a patron, or lack of interest in Greece, must remain an open question. At any rate, Turner never did visit Greece. He was essentially interested in the countries that had traditionally been on the route of the Grand Tour.

Between 1802, when Turner was first able to travel on the Continent as a result of the brief peace of Amiens, and 1845, when he left his homeland for the last time, his main destinations were Switzerland, Holland, Germany, Italy and France; detours also took him to Belgium, Luxem-

13

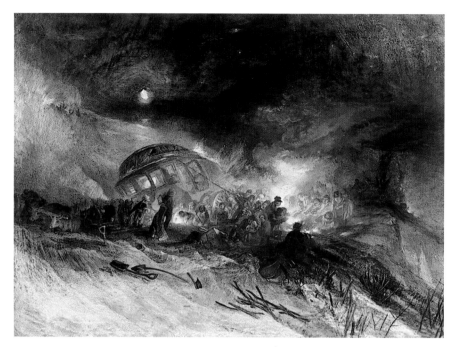

Messieurs les voyageurs on their return from Italy (par la diligence) in a snow drift upon Mount Tarrar, 22nd of January, 1829, R.A. 1829

bourg, Denmark, Austria and Bohemia. The majority of his trips were undertaken in order to collect material for topographical works. For years he was involved with a project on the rivers of Europe, which eventually however was to result in just three volumes on the Loire and Seine rivers of France. The motivation for other journeys arose in part from his reading of Lord Byron, but also as a result of work by fellow artists or a specific commission from a patron. In the final analysis, it was obviously essential for a landscape painter, regardless of any specific project, to explore nature in all its guises and observe its consequences.

In between Turner's almost yearly trips abroad he traveled repeatedly within his own country, here again usually in connection with topographical series, such as *Picturesque Views of the Southern Coast of England* (1811– 26), *The Rivers of England* (1822–27), *The Ports of England* (1825–28) and particularly *Picturesque Views in England and Wales* (1825–39), to name just the most important ones.

Unlike any other artist, Turner depicts not only the landscapes he is traveling through but also, on occasion, the actual business of traveling. Landscape and architecture are not the only subjects worthy of depiction; methods of transport and the inconveniences associated with travel are

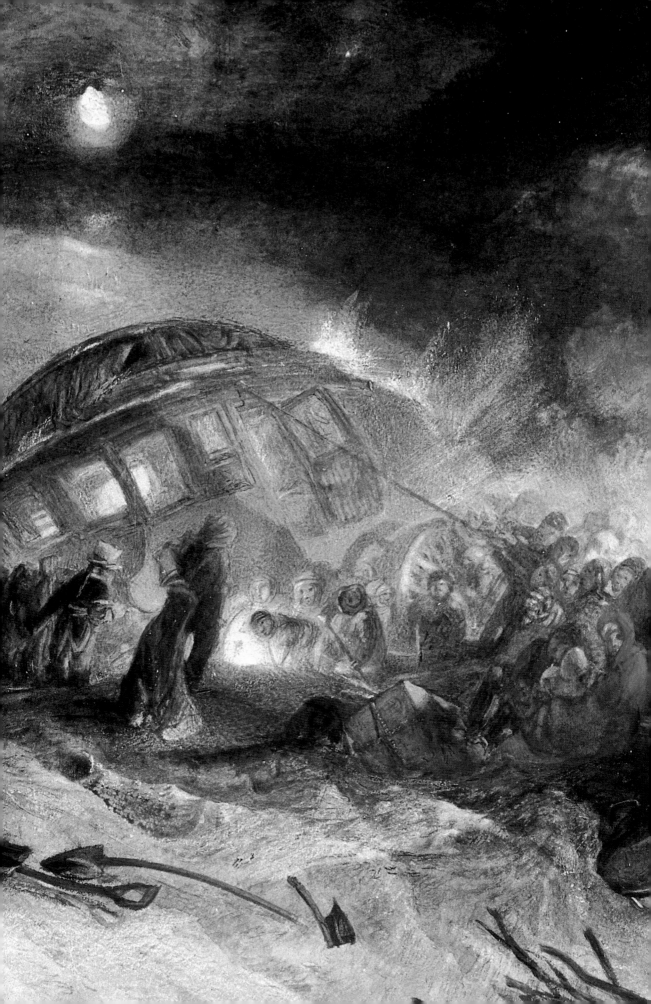

also illustrated. In innumerable works we see the most diverse examples of water-based transport: small fishing boats, boats towed by draft animals or by people, sailing boats, steamboats. Another recurring motif is the carriage, or stagecoach, as an important symbol of the Golden Age of the Grand Tour. And in one of his late works Turner even immortalizes the railway.

As a true child of his time Turner loved to portray catastrophes and thus in several works showed the dangers to which the traveler was exposed en route. He incorporated his own experiences to a considerable degree, emphasizing this in the title of the picture or though added comments. The first evidence of this is *Calais Pier, with French Poissards Preparing for Sea: an English Packet Arriving* (illus.), which resulted from an incident during his trip to Switzerland in 1802. As he was arriving in Calais by boat, Turner was "nearly swampt" (illus.), as emerges from his drawing and from a note in the relevant sketchbook. Only in 1821 – when the first steamships entered service – did the sea crossing to the Continent become safer and more comfortable. In terms of painting, with this work Turner placed himself within the tradition of 17th-century Northern European art with its marine pictures which also played a large part in his own oeuvre. Turner's spectrum ranges from the depiction of large merchant vessels in stormy seas and shipwreck scenes – both favourite subjects in the repertoire of Sublime painting – to peaceful, atmospheric morning or evening seascapes. In its drama and its painterly freedom *Calais Pier* surpasses the work of such Dutch masters as Jacob van Ruysdael (1628–1682) and Willem van de Velde (1633–1707), against whom Turner measured himself and from whom he took his direction. But Turner is not just concerned with depicting a scene of danger, he is also portraying the meeting of two nations which until shortly before had been at war. In choosing the word *poissards* for fishermen he is using a pejorative term which can be translated as 'rabble' or 'riff-raff'. While the frail little French boat is attempting in vain to get away from the pier, another French boat and the fully laden English ferry are trying to avoid a collision – a form of allegorical comedy on the political situation.

When Turner was returning from his first visit to Italy in January 1820 he crossed the pass of Mont Cenis in extremely bad weather. For a long time, crossing the Alps presented a great danger and trial for travelers, so it is hardly surprising that there is such a mass of literary descriptions, some of it verging on adventure literature. By Turner's time the roads

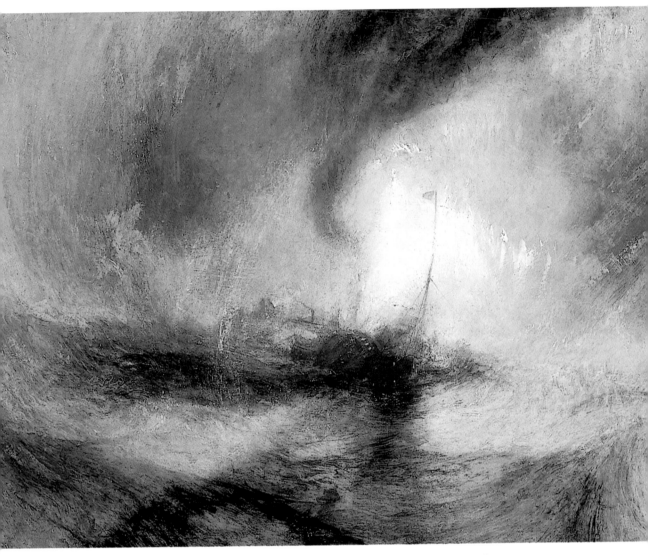

*Snowstorm – Steam Boat off a Harbour's Mouth making Signals
in Shallow Water, and going by the Lead. The Author was in this Storm
on the Night the Ariel left Harwich, R.A. 1842*

were already much improved, but the weather could still hold perils, as
Turner graphically portrays in his watercolor *Passage of Mont Cenis (Snow-
storm)* (illus.). Executed in a monochrome chiaroscuro, it shows two
coaches at the top of the pass that seem about to be caught by a whirlwind
that is breaking forward out of the background. Turner inscribed the work
at bottom right with the words "The passage of Mt Cenis, 15th Jany, 1820".
Years later he reminded himself of the incident in a letter to a friend, the
watercolorist James Holworthy: "Mont Cenis had already been closed to

traffic for some time, even if the newspapers reported that a month before some hot-headed Englishmen had dared to cross it on foot, which the locals considered half madness, a honour that was extended to me and my companions when we set out in the carriage. At the peak we turned over. We were lucky that it happened; the carriage doors were so completely frozen that we had to climb out through the windows…"[11] When he interpreted this in picture form, Turner left out the detail that the carriage had overturned, focussing all his interest on the storm that is making the horses shy. All the same, Turner does not mention this snowstorm in his letter, and we have to ask ourselves if it was not just an invention on his part intended to heighten the sense of drama.

An even more dangerous and unusual experience as he was crossing the Alps in 1829 inspired him anew: "Now, about my journey home. Believe me, no poor devil ever had one like mine, but at least it was instructive in one respect, namely never again to set out so deep in the winter … the snow began to fall at Foligno, more ice than snow, so that the weight of the coach made it slide about in all directions. Walking would have been much preferable, but my innumerable tails would not do that service, so I soon got wet through and through, until at Sarre-valli the diligence slid into a ditch, and required six oxen, sent three miles back for, to dig it out … We crossed Mont Cenis on a sledge – bivouacked in the snow with fires lighted for three hours on Mont Tarare while the diligence was righted and dug out, for a bank of snow saved it from upsetting …"[12]

Turner utilized this experience in a watercolor with the humorous title *Messieurs les voyageurs on their return from Italy (par la diligence) in a snow drift upon Mount Tarrat, 22nd of January 1829*. In a typical association he contrasts the cold of the snow, the inhospitable nature of the icy Alpine landscape, with the glowing heat of the fire at which the travelers are warming themselves. He supposedly immortalized himself in this picture in the figure of the man wearing a hat and sitting with his back to the viewer – as the person affected, an observer and the painter of the scene.

While, in the above-mentioned works, Turner portrays his travel experiences under extreme weather conditions on the sea and in the sublime world of the mountains and thus lends a personal note to the theme of man threatened by nature, in two other pictures that were produced in the 1840s his interest in technology and progress comes to the fore.

The high point of his predilection for stormy seascapes and his preoccupation with steamships is, without any doubt, the oil painting entitled

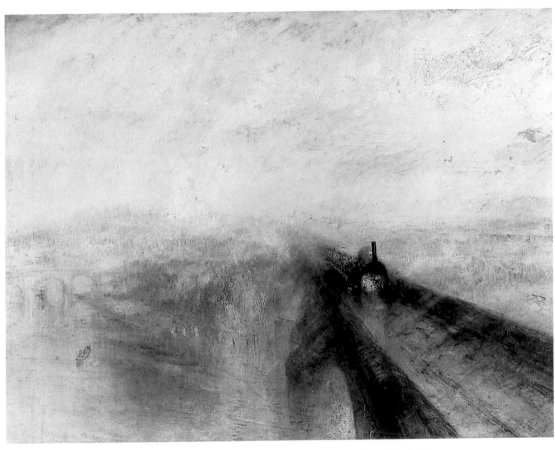

Rain, Steam and Speed – The Great Western Railway, R.A. 1844

Snowstorm – Steam-boat off a Harbour's Mouth Making Signals in Shallow Water, and Going by the Lead. The Author was in this Storm on the night the Ariel Left Harwich (illus.). It was shown in 1842 at the Royal Academy, where it attracted the most vehement criticism: "On earlier occasions this gentleman was wont to paint with cream or chocolate, egg yolk or black-currant jelly – here he offers his entire battery of kitchen equipment. Where the steamship is – where the harbour begins or ends – what the signals are and which is the author on the Ariel ... all this, unfortunately, cannot be determined."[13] Quite obviously, with this painting Turner had made excessive demands of his contemporaries' perceptive capabilities and power of imagination. In a radical manner he dispenses with all the patterns of a traditional composition. Water, snow and steam, swirling in a circle like a whirlpool, merge into an atmospheric phenomenon. The wildness of what is happening can be sensed in the impetuosity of the brushstrokes. How-

ever, in order to emphasize the truth of the scene, Turner gave the picture the long, explanatory title with which for the first time he expressly underlined the fact that he himself had experienced what he portrayed. To back this up still further he reported as follows: "I got the sailors to lash me to the mast to observe it [the stormy sea]: I was lashed for four hours, and I did not expect to escape, but I felt bound to record it, if I did."[14] With this story, which he may well have invented, Turner placed himself within a popular tradition of marine painting: tales of this type were told about such painters as Ludolf Backhuysen (1631–1708) and Claude-Joseph Vernet (1714–1789).

A similar homage to modern technology is found in the famous second "key picture on the steam revolution" (Wolfgang Häusler): *Rain, Steam and Speed – The Great Western Railway*. This painting was shown at the Royal Academy in 1844 and can be considered the first representation of speed and movement in the history of art.[15] As mentioned earlier, railways were no longer an absolute novelty by that time, either in England or on the Continent, but previously no artist had been moved to paint them. After Adolph von Menzel's picture of 1847, a prosaic depiction of the railway between Berlin and Potsdam, the next to become involved with the theme in a similarly innovative way would be Claude Monet in the 1870s. Turner's picture shows the viaduct of the Great Western Railway over the Thames between Maidenhead and Taplow. Turner knew its builder, the engineer Isambard Kingdom Brunel, and was fascinated by his projects, for example the construction of an ocean-going steamer. The picture is based on personal experience: during a thunderstorm Turner held his head out of the window of his carriage for minutes at a time in order to feel the sensation of the speed and the weather. And, like the Snowstorm, produced two years earlier, here again he amalgamates the depiction of extreme weather conditions with the portrayal of a modern method of transport.

If we compare Calais Pier and Rain, Steam and Speed, which were painted more than 40 years apart, we also see a reflection of the lightening speed of the developments that England had experienced, taking it from being an agrarian state to the leading industrial country in Europe. In 1826 the Berlin architect Karl Friedrich Schinkel (1781–1841) had set out for England to study its modern developments in construction and industry, which were considered exemplary in Germany. While Italy with its cultural and scenic beauties remained the classic destination for tourism and

educational purposes, it was to England that one went if one wanted to study the advances that had been made made in trade, industry and architecture.

Turner devoted himself both to the Sublime and to picturesque beauty, but he did not shut his eyes to the new, and he understood how to translate what he had himself seen and experienced into art in the most diverse manner.

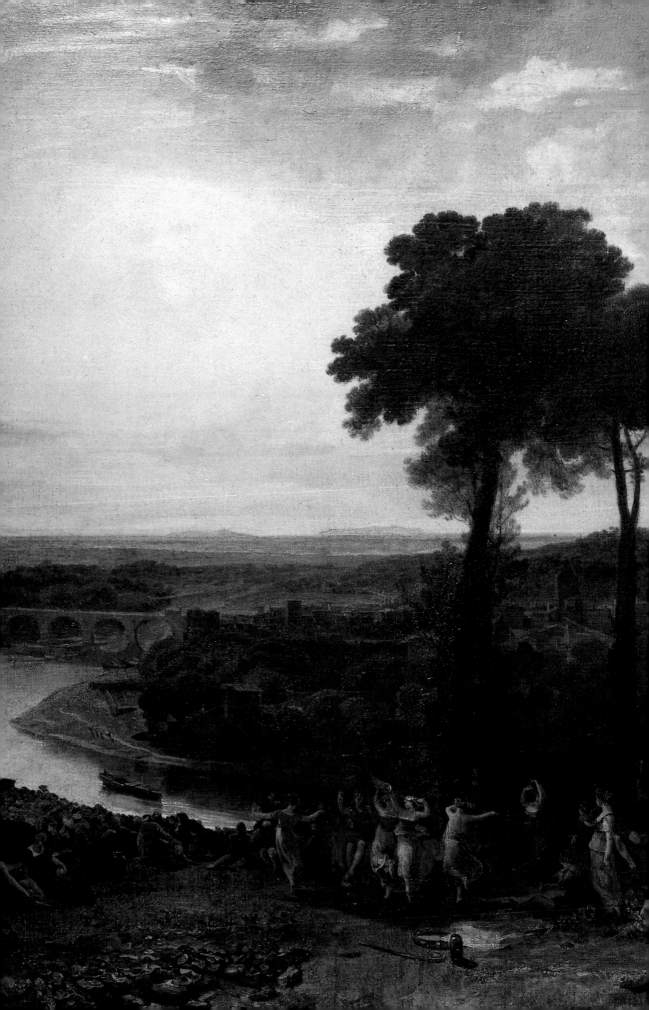

THE FIRST JOURNEY ON THE CONTINENT, 1802

'…precipices very romantic, and strikingly grand…'

Following the Treaty of Amiens in 1802 it again became possible to travel in safety on the Continent, and Turner was one of the many Britons who seized the opportunity without delay. His destination was Switzerland which, with its grandiose mountains, was the country that for him most completely encapsulated the concept of the sublime landscape.[16] For a long time considered merely a troublesome obstruction on the way to Italy, the Alpine landscape had begun to attract greater attention from travelers, writers and artists. In addition to German, French and Swiss landscape painters, during the last decades of the 18th century such British artists as William Pars (1742–1782), John 'Warwick' Smith (1749–1831), Francis Towne (1740–1816) and John Robert Cozens were drawn by the unusual qualities of the scenery. Through the work of these artists Turner had been able to picture the country for himself long before he went there. Of particular significance were Cozens' watercolors, which Turner had copied while studying at Dr Monro's 'Academy' in the 1790s.

Detail of illustration on page 24

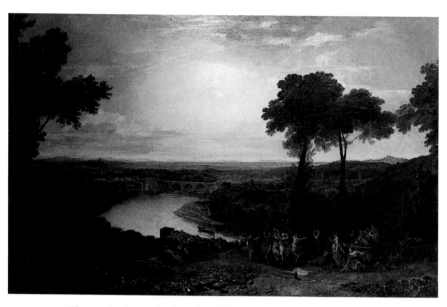

The Festival upon the Opening of the Vintage of Macon, R.A. 1803

Turner left London in mid-July, and as early as the crossing to Calais was presented with a subject which he made into a painting after his return home (illus.). In Paris he made the acquaintance of a wealthy young Englishman named Neweby Lowson, and they decided to continue the tour together. Lowson hired a coach and a Swiss guide, conveniences that Turner could not afford on his later, solo journeys. From Paris their route took them via Tournus, Macon and Lyons to Grenoble. Up to that point Turner had made a few pencil sketches, but this was where the productive part of the journey began. From Geneva the pair traveled via Bonneville, Sallanches and Chamonix to Mont Blanc, then from Aosta over the Great St Bernard Pass via Martigny and Chillon to Lausanne, and on to Bern, Thun, Brienz and Lucerne. They made detours to the St Gothard Pass and the Rhine Falls at Schaffhausen before leaving the majestic mountains behind at Laufenburg. The return Paris took nearly five days, and Turner – as on the outward leg – was able to glean little from the landscape.

Back in Paris, at the end of September he met up with his colleague Joseph Farington and described for him his journey, which Farington then set down in his diary: "Turner called. He was three days at Lyons. He thinks little of the River Rhone at that place; but the views of the Saone are fine. The buildings of Lyons are better than those of Edinburgh, but there is nothing so good as Edinburgh Castle. The Grande Charteuse is fine; so

is Grindelwald in Switzerland. The trees in Switzerland are bad for a painter, – fragments and precipices very romantic, and strikingly grand. The country on the whole surpasses Wales; and Scotland too…" Apart from discussing and comparing the special characteristics of the lanscape, they also naturally talked about everyday matters. "He found the Wines of France and of Switzerland too acid for his Constitution being bilious. He underwent much fatigue from walking, and often experienced bad living & lodgings. The weather was very fine. He saw very fine Thunder Storms among the Mountains."[17]

Before Turner returned to London, like Farington and many other painters he studied the art treasures that Napoleon had collected from all over the world and placed in the Louvre. Turner was particularly interested in the works of Raphael, Correggio, Giorgione, Titian, Poussin, Ruysdael, Rembrandt and Rubens. He filled one of his sketchbooks with studies and color schemes after paintings by these artists and took copious notes on the effect of certain pictures. The masterpieces he saw in Paris acted as his standard and guideline, as is clearly shown by the paintings that he created once he was back in London and exhibited at the Royal Academy. Whereas *Calais Pier* (illus.) owes a debt to the Dutch masters,

Claude Lorrain (1600–1682), Pastoral Landscape
with the Ponte Molle, 1645

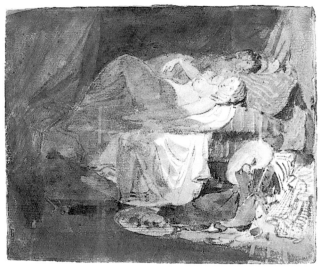

Swiss Figures, Swiss Figures' Sketchbook, 1802

The Festival upon the Opening of the Vintage of Macon (illus.) represents his homage to the revered Claude Lorrain (of whose works incidentally, and most surprisingly, he did not make any studies during his stay in Paris). The landscape is shown against the light in a broad panorama. In a manner comparable to that of Lorrain's classical pastoral landscapes (illus.), framing groups of trees and figure staffage appear in the fore ground while a river draws the viewer's gaze into the distance.

In all, during this tour lasting almost three months Turner used nine sketchbooks of varying sizes and filled them with more than 500 drawings. He worked systematically, since he wished to be able to draw on this

Glacier and Source of the Arveiron, going up to the Mer de Glace, R.A. 1803

material as a basis for watercolors and oil paintings years hence. The fact that he was also interested in people and their dress is shown by the so-called *Swiss Figures' Sketchbook* (illus.), in which Turner recorded figural studies, mostly in color. The majority of these sketches must have been done on a festival day.

Whereas in some of the sketchbooks Turner recorded landscape and urban views in a relatively cursory fashion with a pencil and inscribed them for identification, in his *Grenoble Sketchbook* and *St Gotthard and Mont Blanc Sketchbook* he worked up more careful compositional studies. Both these sketchbooks were prepared with a grey ground and contained drawings laid down in pencil and then worked over with dark chalk or white gouache, as well as more finished studies for which he used watercolor and bodycolor.

Back in London, Turner started to process the material he had collected. He put together a selection of the best drawings from the two above-mentioned sketchbooks in a captioned album so that he could show them to potential customers. And he was successful: one of his first buyers was Walter Fawkes, a landowner from Yorkshire, who was to become not just one of Turner's most important collectors but also a close friend. By 1820 Fawkes had acquired a total of twenty works on Swiss themes, including a watercolor which Turner presented at the Royal Academy exhibition of

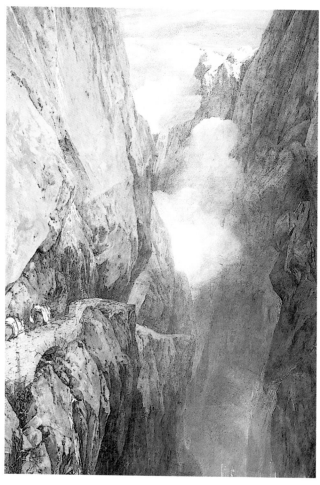

The Schollenen Gorge from the center of the Devil's Bridge,
St Gothard and Mont Blanc sketchbook, 1802

1803 and which was also based on a sketchbook study. It depicts glaciers
and the source of the Arveiron on the way up to the Mer de Glace (illus.).
The dark, skeletal trees, more dead than alive, seem barely able to with-
stand the scale and might of the cloud-shrouded mountains. A few goats,
accompanied by a goatherd represented as puny by comparison with na-
ture, forage for meagre nourishment in the barren landscape. The leaf,
rich with tonalities, shows what a subtle delicacy Turner had already
achieved in his handling of watercolor. In his efforts to lift watercolor paint-
ing to the same status as the more refined painting in oils he had developed
a variety of special techniques, not least a method of producing lights
by scratching out the excess colour with his famously long thumbnail.
One subject to which Turner devoted himself intensively in several works

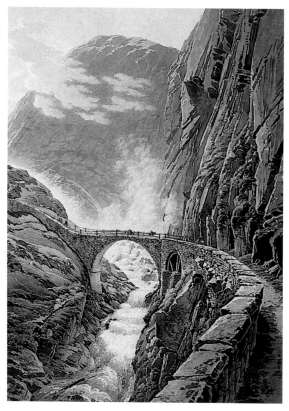

Gabriel Lory the younger (1784–1846),
The Devil's Bridge in the Schollenen, 1827

and which seemed particularly appropriate to symbolize the threatening sublimity of the mountains was that of the precipice and the ravine. Again basing his work on a study from the *St Gotthard and Mont Blanc Sketchbook* that shows the St Gotthard Pass from the Devil's Bridge, he created both a watercolor (illus.) and an oil painting on this theme. The viewer seems to be suspended above the abyss. The narrow ravine is dark and shrouded in clouds; only at the upper edge is a small patch of blue sky visible, and sunlight falls solely on the steep rocks at upper left. Below, the walled pass road winds along, appearing to lead directly into the depths. No limits are set to the upward swoop of the cliffs by the partial view presented by the vertical format, nor can the bottom of the ravine be distinguished.

Turner also recorded in his sketchbook the view from the pass road across to the Devil's Bridge – one of his favourite subjects, together with the icefield, the Mer de Glace – and used it for a watercolor and an oil

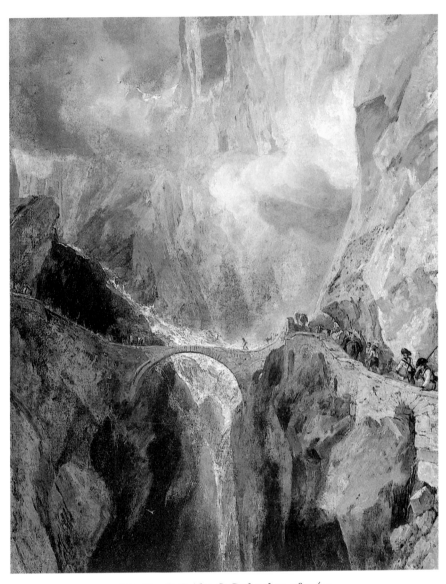

The Devil's Bridge, St Gothard, ca. 1803/04

painting (illus.). Destroyed in 1799 during a battle between the Russians and French, the bridge had just been rebuilt when Turner visited the pass in 1802. By introducing a column of soldiers climbing the pass, he reminds the viewer of the military engagement and demonstrates that he was not just interested in this scene as a landscape but as the site of highly topical political events (he also visited the Great St Bernard Pass, which Napoleon had crossed in 1800). In Turner's oil painting a soldier on the right edge of the picture is gazing down with a shudder of horror into the abyss, while another soldier is setting out to cross the bridge like a tightrope

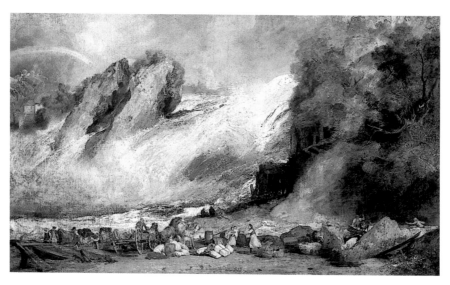

Fall of the Rhine at Schaffhausen, R.A. 1806

walker. Bereft of railings, the bridge stretches over the deep ravine
through which the rushing water carves its way, with no trace of vege-
tation. Dark, swirling clouds seem to presage rain or a thunderstorm. In
short, the threatening, awe-inspiring and simultaneously fascinating is
here portrayed in a monumental fashion, but full credit is also given to
the human achievement in making this world accessible.

The extent to which Turner exaggerated reality is shown by compari-
son with an 1827 watercolor (illus.) by the Swiss landscape painter Gabriel
Lory (1784–1846). Whereas Turner's viewpoint would appear to be that
of a bird soaring above the ravine, the viewer in Lory's picture stands firm
and safe on the road. Matching the reality, the ravine is not nearly so deep
and narrow, the slopes betray at least a hint of green, and the mountains do
not – as in Turner's picture – rise immeasurably high into the sky.

Turner's enthusiasm for waterfalls, which like the stormy sea could
express in visual terms all the mysteriousness and wildness of nature,
reached its climax in his encounter with the Rhine Falls at Schaffhausen,
the largest waterfall in Europe. In an oil painting (illus.) exhibited at the
Royal Academy in 1806 Turner reworked the impressions gathered on his
journey in his customarily exaggerated manner. The impression of an ex-
traordinary event that threatens to assume the dimensions of a biblical
flood is intensified by the thunderclouds gathering on the left in front of
which there is a rainbow. The behavior of the people and animals in the

foreground also contributes to this effect: shying horses, a recalcitrant sheep and a crying baby reflect the tumultuous elements.

A painting shown four years later at the Royal Academy, *The Fall of an Avalanche in the Grisons* (illus.), is related to this picture in the drama of the events it portrays. If the first picture falls within the tradition of topographical landscape painting, this second one is the pure depiction of a catastrophe. Even if it does stem from Turner's Swiss experiences, it arises less from his own experiences than from his imagination stimulated by his journey. He did not go to the Grisons in 1802, but the picture is in any case not concerned with the exact portrayal of a specific region. Turner may have been motivated to produce this painting by the report of an avalanche which buried 25 people in Selva in the Grisons in December 1808. Furthermore, with this painting he was competing against an oil painting (illus.) by Philip Jacques de Loutherbourg (1740–1812), also on the theme of an

The Fall of an Avalanche in the Grisons, R.A. 1810

33

avalanche, which had been exhibited at the Royal Academy in 1803. Just like Turner, Loutherbourg – who had settled in London in 1771 from his native Fulda – had a pronounced bent for portraying dramatic natural occurrences. Compared with Turner's apocalyptic depiction, however, Loutherbourg's snow masses seem fairly harmless, despite the theatrical gestures of the threatened humans in the foreground. Loutherbourg's stage-like, easily comprehensible layout contrasts with Turner's composition consisting of diagonals which however does not permit clarification of the spatial relationship. The power of the scene is matched by the unconventional technique: the surface is worked by means of scratching, scraping and tearing with the spatula, brush handle or thumbnail to give adequate expression to the uproar of the elements. Here Turner is responding by unusual means to the demand for visual terror in sublime landscape painting.

How many-sided Turner's activities were is demonstrated in other watercolors and oil paintings which disseminate a cheerful, idyllic mood. The Lake of Brienz (illus.), a watercolor produced in 1809, is one of these Swiss examples in which sublime wildness is replaced by sun-drenched, lyrical views with a southern flair. Turner depicts in detail the happy hustle and bustle of the people on the bank of the peaceful lake. The moun-

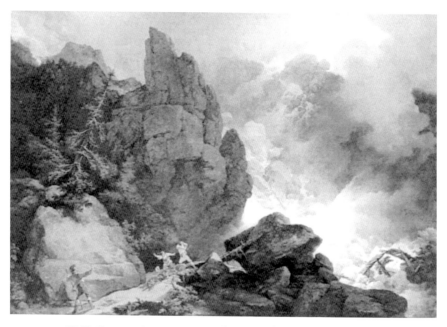

Philip Jacques de Loutherbourg (1710–1812), The Avalanche, 1803

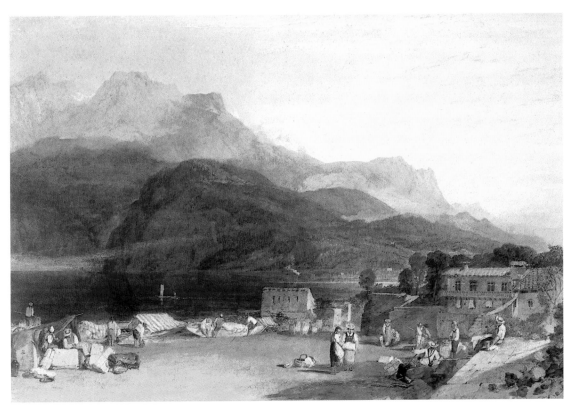

The Lake of Brienz, 1809

tains command the background of the composition, it is true, but they do not appear to present any threat. In such works Turner contrasts the barrenness of inhabitable regions with the picturesque landscape cultivated by human hand in which man and nature are in harmony.

Turner's first tour on the Continent had a great influence on his artistic development. Both his study of the great masters in Paris and his exploration of the Alpine landscape determined what he painted in subsequent years. This first journey abroad was not succeeded by another for a long time. After the brief interlude of peace, the following years were completely dominated by the conflict between the French armies on the Continent and the might of the British navy. The blockade that Napoleon pronounced against the British in 1806 put a stop to travel on the Continent, and only in 1815 did the military conflict come to an end with Napoleon's defeat at Waterloo.

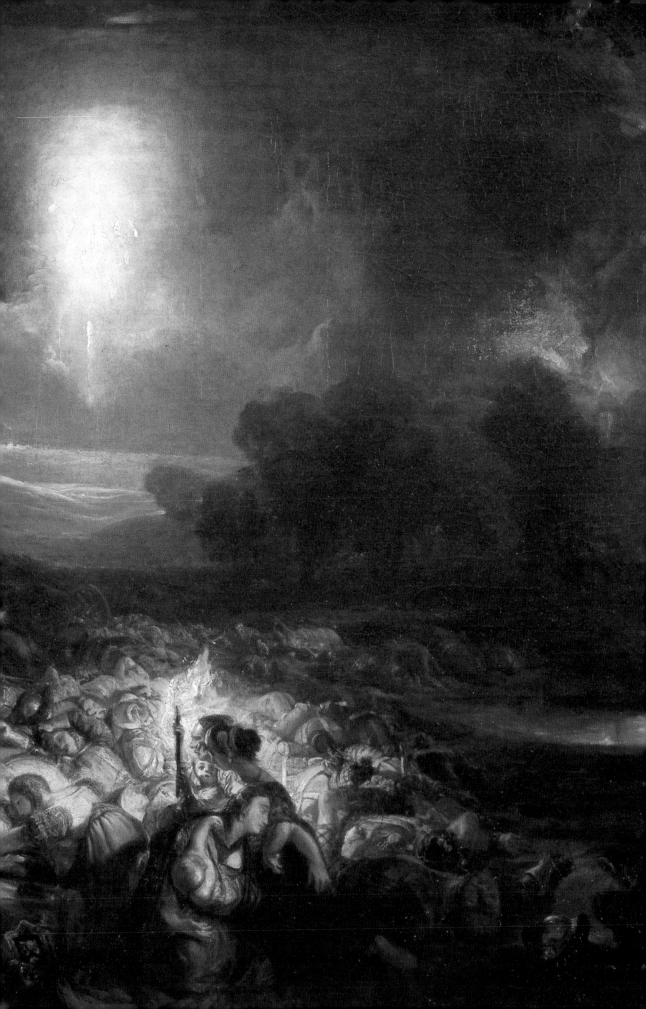

Waterloo and Rhine, 1817

"Maternal Nature! for who teems like thee, thus on the banks of thy majestic Rhine!"

When Turner left London in August 1817 to visit the Continent again after the enforced break of many years, he was very well informed and prepared, unlike his Swiss trip, which had been planned at short notice. His goals were Waterloo and the Rhine, and in both cases he would be following in Lord Byron's footsteps.[18] The epic poem 'Childe Harold's Pilgrimage' in which Byron commented on the political events of the day and rendered his travel impressions in poetic form had – as mentioned above – totally overwhelmed his British public. Travel guides of every type, down to Murray's *Handbooks* of the 1830s, quoted the relevant lines from the poem against the appropriate location. Byron had sung the praises of his trips to Portugal, Spain and Greece in his Canti I and II, published in 1812. In 1816 the poet was one of the first to visit Waterloo, the Rhineland and Switzerland after the cessation of war. In that same year Canto III appeared, in which Byron lauded the beauties of the Rhine in the lines:[19]

Detail of illustration on page 39

Maternal Nature! for who teems like thee,
Thus on the banks of thy majestic Rhine?

But he also lamented the senselessness of war ("Rider and horse, – friend,
– foe, – in one red burial blent!"[20]).

The Rhineland had gained a new political significance against the
backdrop of the Napoleonic Wars as the German-French border-cum-
occupation zone.[21] The river rapidly became a national symbol of the
German desire for freedom from the French occupier. Even before Byron,
Clemens von Brentano (1778–1842) and Achim von Arnim (1781–1831)
had discovered the scenic charms of the Rhine when they traveled down it
in 1802. Friedrich von Schlegel (1772–1829), too, had visited the Rhine
that year and wrote enthusiastically: "The really lovely Rhine region be-
gins at friendly Bonn; a richly decorated, broad corridor which stretches
like a great ravine between hills and mountains for a day's journey up to
where the Moselle flows into it at Koblenz; from there to St Goar and Bin-
gen the valley becomes ever narrower, the cliffs steeper, and the region
wilder; and it is here that the Rhine is at its most beautiful … Nothing how-
ever can beautify and intensify the impression more than the traces of
human audacity on the ruins of nature, bold castles on wild crags."[22]

In the light of political events, but also because of its esthetic reevalua-
tion by the Romantic movement in the first decades of the 19th century,
the Rhine became a regular tourist attraction. This went hand in hand with
improvements in transport: under Napoleon a road with strong founda-
tions had been built along the left bank of the Rhine between Mainz and
Koblenz for military purposes, while water-borne traffic was given a new
dimension with the introduction of steamboats. The plethora of Rhine
travel literature and engravings which appeared in the first half of the 19th
century is thus hardly surprising.

To prepare for his trip Turner consulted a number of sources of in-
formation.[23] First he purchased a guidebook which had just appeared in
its second edition, *The Travellers Complete Guide through Belgium and Hol-
land … with a Scetch of a Tour in Germany*, by Charles Campbell. Another
book – also published in 1817 – that Turner acquired was J. Mawman's *A
Picturesque Tour through France, Switzerland, on the Banks of the Rhine, and
through Part of the Netherlands*. Two further sources were the illustrated
volumes *Scetches in Flanders and Holland …* by Robert Hills, and *Views
taken on and near The River Rhine, at Aix la Chapelle, and on the River Maese*

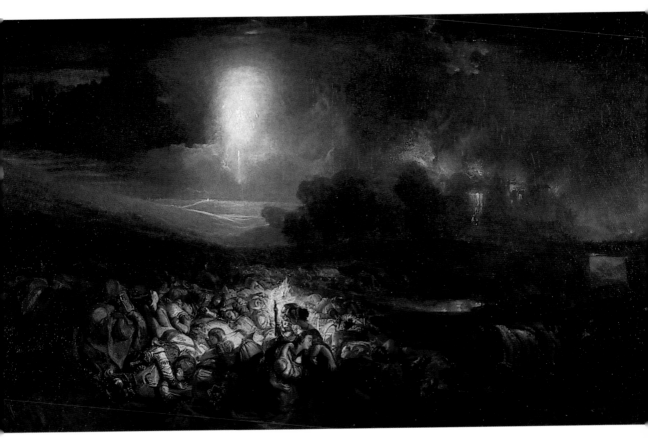

The Field of Waterloo, R.A. 1818

by John Gardnor, published between 1788 and 1791, and again in 1792. Gardnor's illustrations of the Rhine enjoyed particular success and had a decisive influence on the British image of the Rhine.

Finally, Turner bought three sketchbooks of varying sizes. In the smallest he not only entered a precise timetable, thanks to which the course of his journey is extraordinarily well documented, he also jotted down remarks on sights worth seeing, lodgings, currencies and other things that might be of use to him during his tour. As this time he was going to be traveling alone and without a guide who knew the country and the language, he also noted down a few phrases and terms such as, for example, "Can I here essen?". Most of the notes came from Campbell's and Gardnor's guidebooks, and it is clear that he followed the routes suggested by these two authors for many stretches of his journey.

Turner left London on 10 August and made the sea crossing from Margate to Ostend. He visited Bruges, Ghent and Brussels and then followed

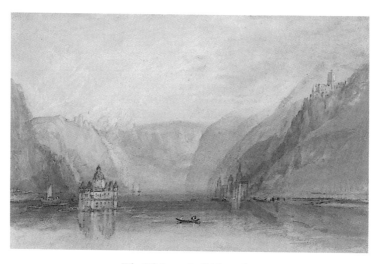

The Pfalz on the Rhine, 1817

Lord Byron's trail to the battlefield at Waterloo where Napoleon was finally defeated by British and Prussian troops in 1815. Turner's great interest in the course of the battle and in the appearance of the bare battlefield initially took the form of innumerable pencil sketches on 17 pages of his sketchbook. After his return home he began a large-format oil painting (illus.) which he showed at the Royal Academy in 1818. In the catalog he quoted the appropriate lines from Byron's Canto III, just as Campbell had done in his guidebook. Turner's picture should not however be understood merely as an illustration of Byron's lines; rather it emphasizes Turner's intellectual kinship with the poet he admired. This is no conventional battlefield scene: it does not show the battle, nor does it celebrate victory.

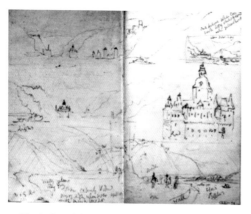

Kaub the Pfalz and Burg Gutenfels; Osterspay and Feltzen, Waterloo and Rhine sketchbook, 1817

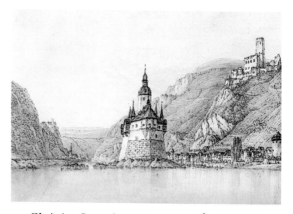

Christian Georg Saütz the younger (1758–1823), The Pfalz at Kaub with Burg Gutenfels, 1818

Loreley and St Goarshausen, 1817

Instead, Turner portrays the night following the battle, with smouldering ruins and women seeking survivors by torchlight among the mountains of corpses. What linked Turner with Byron was the conviction of the futility of human striving for power ("How in an hour the Power which gave annuls Its gifts, transferring fame as fleeting too!"[24]).

From Waterloo Turner traveled on via Aachen to Cologne. Over the following twelve days he devoted himself to intensive study of the Middle Rhine as far up as Mainz. Although he did the stretch upstream on foot, except for the last part, on the return journey from Mainz to Cologne he travelled largely by water.

From Cologne he traveled via Aachen and Liège to Antwerp. A final detour before returning home took him to the northern part of the Netherlands, via Rotterdam, The Hague, Leiden and Haarlem to Amsterdam, and thence back via Utrecht.

Apart from the two oil paintings, Turner produced no less than fifty watercolors on themes connected with the Rhine following his tour. In his characteristic manner he laid down broad washes of transparent watercolor and areas of milky bodycolor on the almost exclusively grey-ground paper. He added details with fine brushstrokes in an application of drier pigment and produced lights, either with lead white or by scratching them out. The entire series was bought by Walter Fawkes during Turner's visit to his country seat, Farnley Hall, in the winter of that same year. For a long time, given the spontaneous style of painting and the differentiated, atmospheric depiction of light effects, it was believed that these watercolors

were painted on the spot, but it is now considered definite that Turner prepared them immediately after his return on the basis of his pencil sketches. All the themes can be traced back to one or more studies in the sketchbooks: for example, the watercolor *The Pfalz on the Rhine*, in which various sketches made *in situ* are combined (illus.).

Although in selecting his subject matter, despite special emphases and preferences, Turner for the most part adhered to the traditional canon of sights, his Rhine watercolors differ considerably from those of his predecessors and contemporaries. Whereas, for example, Christian Georg Schütz the younger (1758–1823) in a view (illus.) painted in 1818 sets the Pfalz centrally in the picture, as though seen from the river, and portrays the architectural and scenic elements in detail, Turner's depiction is characterized by the diffuse, atmospheric mood which places much more value on light effects and on color than on the painstaking reproduction of the topography. Turner here is not just painting an extremely picturesque subject but – as a person knowledgable about recent events – is portraying a place of historical importance. This is where Marshal Blücher crossed the Rhine with his army on New Year's Eve 1813/14 to start the offensive against the French occupation which finally ended at Waterloo.

Another of Turner's special favorites was the Loreley, the most famous rock along the Rhine, to which he accorded particular importance within the series with seven works. Feared because of its dangerous depths and the rocks hidden below the water, this was a particular attraction, mysticized even further by the legend of the siren who lures men to their death with her beauty and her singing. Invented around the turn of the century by Clemens von Brentano, the siren figure received its popular expression, persisting to the present day, in Heinrich Heine's song 'Ich weiss nicht was soll es bedeuten', published in 1824. Whether Turner had heard of the legendary figure remains open to debate, but it is certain that the monumental size of the rock jutting out of the dangerous waters attracted him as if by magic as the ideal embodiment of the Sublime. In one watercolor (illus.), Turner portrays the topography as fjord-like. Dark, sublime and awe-inspiring, the rock soars to the top of the picture on the right. In the background St Goarshausen and Castle Katz are visible, illuminated by a temporary break in the clouds that cover the sky.

Turner included only two views of cities in this series. One leaf is devoted to Mainz, while another watercolor, lost for a long time, shows a view over Cologne (illus.). On the left the Bayenturm is set in the picture

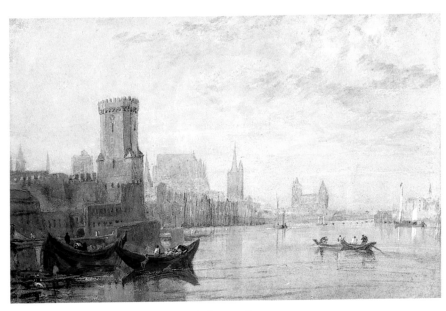

Cologne, 1817

in such a way that it separates the two sections – still under construction – of the uncompleted cathedral, with the choir and south tower behind. Through this arrangement Turner deliberately emphasizes the building's significance. The German Romantic movement's enthusiasm for Gothic found a national monument when work on this building, which had remained unfinished since the mid-16th century, was resumed in 1808.

Turner repeated sundry themes from his Rhine series, including the Cologne view, in subsequent years – in more detail and in larger format. Sometimes these were commissioned by collectors, sometimes they were done in connection with a book project planned by the publisher John Murray and the graphic arts dealer William Bernard Cooke. However this project, for which Turner was supposed to provide 36 Rhine views as designs for engravings, was abandoned around 1820, as *A Picturesque Tour along the Rhine, from Mentz to Cologne* had just appeared on the English market with 24 etchings after drawings by the above-mentioned Christian Georg Schütz (illus.) and with a text by Baron Johann von Gerning. Still, Turner's interest in the Rhineland was not dampened by this setback. Even in later years, as he was returning from Italy or Switzerland, the Rhine landscape continued to provide him with material for watercolors and designs for engravings. However, it was two other Englishmen, Robert Batty (1789–1848) and Clarkson Stanfield (1793–1867), who would create series of topographical engravings of the Rhine in the 1820s and 1830s.

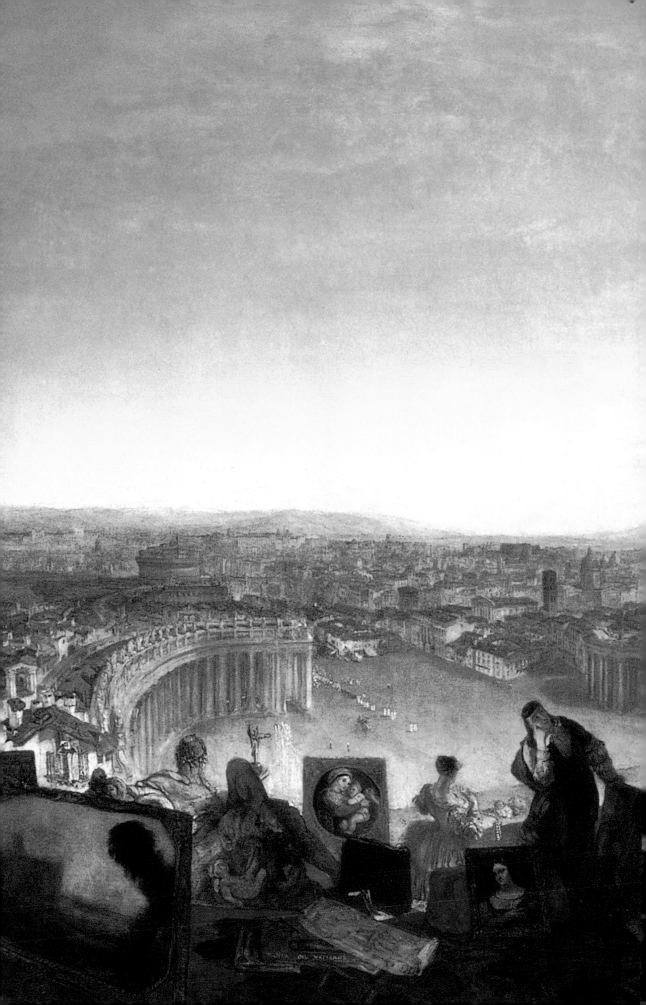

ITALY, 1819

*"Turner should come to Rome. His genius would here be supplied with materials
entirely congenial to it …"*

In the summer of 1819 Turner left London with the aim of visiting Italy,
a country in which he had long been interested.[25] Its cultural riches and
scenic charms had made it the climax, the final destination, of the Grand
Tour, and Rome had become a center for artists of any and every origin.
Since his early years Turner had been familiar with Italy's landscapes and
cities through the works of such British artists as Richard Wilson, John
Robert Cozens, Francis Towne and William Pars. His preoccupation
with the work of Claude Lorrain had moreover had a pronounced influ-
ence not only on his concept of landscape painting but also on his ideas
about Italy's Mediterranean ambience. His interest had been aroused in
particular by his acquaintance with Sir Richard Colt Hoare, one of his first
patrons and supporters, who had himself traveled in Italy, made drawings
there and published his experiences in the form of a book.

 Years before this trip Turner was already producing works on Italian
subjects. In *Landscape: Composition of Tivoli* of 1817 he is directly refering

*Detail of
illustration
on page 53*

The Grand Canal, looking towards the Rialto, 1819

to the fact that, although he has some topographical knowledge about the place, this is not based on his own experience.

In 1818 he was commissioned to undertake a project that must have intensified his desire to see the famous sites with his own eyes. For James Hakewill's *Picturesque Tour in Italy*, which was published with great success between 1818 and 1820, he prepared 18 watercolors as designs for engravings after his drawings in pencil. It was James Hakewill who provided Turner with travel tips and information before he left; he even wrote down the most important for him in a sort of travel guide in one of Turner's sketchbooks. Turner also drew on other literature, such as *Select Views in Italy* of 1792–96 by John 'Warwick' Smith, William Byrne and John Emes, and J.C. Eustace's *Tour through Italy*, the third edition of which had appeared in 1817. From these he copied sketches and notes into a small, handy sketchbook that he could carry about with him on his journey.

The publication of Canto IV of Byron's 'Childe Harold's Pilgrimage' undoubtedly acted as a further spur to undertake the trip to Italy at last. This final part of the epic poem, dedicated to Italy, appeared in the spring of 1818 as Turner was preparing the watercolors for Hakewill. Reading it must have not only inspired his work but also made him decide yet again to follow in the poet's footsteps. Turner's Academy colleague Sir Thomas Lawrence (1769–1830) remarked in a letter from Italy to Joseph Farington: "Turner should come to Rome. His genius would here be supplied with materials entirely congenial to it ..."[26]

Turner's trip – he left London on 31 July 1819 and returned on 1 February 1820 – is comprehensively documented in the almost 2000 sketches (around 60 of them in color) with which he filled more than 20 sketchbooks of various formats. From Calais he traveled by carriage via Paris to Lyons and crossed the Alps by the pass of Mont Cenis. After brief stays in Turin and Milan, from where he made an excursion to the Italian lakes, he

46

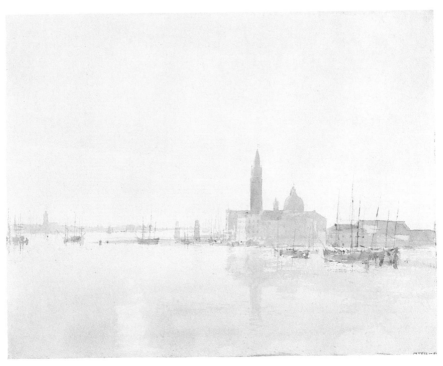

Venice: San Giorgio Maggiore:
Morning, 1819

reached Venice on 8 or 9 September and left it again on the 12th or 13th of
that month.[27] The lagoon city's popularity with British travelers in the
first half of the 19th century was essentially due to the influence of Lord
Byron. But such works as Wordsworth's 'Ode on the Extinction of the Ve-
netian Republic' and Shelley's 'Lines Written among the Euganean Hills'
had also aroused interest. Although a visit to Venice had been an impera-
tive for travelers since the 17th century, the stream of visitors had declined
at the end of the 18th century with the rise of Classicism: Rome had
become the absolute center of the arts. The falling interest in the art of
Venice was linked to the political and economic decline of the city, which
reached its nadir with the dissolution of the Republic and its occupation
by the French and Austrians. "Seldom is a palace well preserved …
The decay of Venetian trade must strike any stranger on seeing the city.
Impoverishment and reduced circumstances are evident everywhere and
leave a bad impression" wrote Karl Friedrich Schinkel during his trip to
Italy in 1802.[28] Travelers tended to avoid the city, but this very circum-
stance attracted Byron, who lived in Venice from 1816 to 1819 and there
compiled his Canto IV, which begins with the words:[29]

The Facade of the Pantheon,
St Peter's sketchbook, 1819

I stood in Venice, on the 'Bridge of Sighs';
A Palace and a prison on each hand:
I saw from out the wave her structures rise
As from the stroke of the Enchanter's wand:
A thousand Years their cloudy wings expand
Around me, and a dying Glory smiles
O'er the far times, when many a subject land
Looked to the winged Lion's marble piles,
Where Venice sate in state, throned on her hundred isles!"

During his stay in 1819 Turner recorded the sights of the city, its palaces, piazzas and bridges, in numerous pencil sketches (illus.). Significantly, he did only four watercolor studies. In no way do these reflect Byron's melancholy view but are of a freedom, beauty, economy and light transparency unlike any of Turner's watercolors up to that date. One of these works is a view from the entrance of the Grand Canal to San Giorgio Maggiore (illus.). Turner laid the shapes down on paper in a free wash without first sketching the scene in pencil. In order better to capture the blinding brilliance of the light he dispensed with his customary grey ground. His main interest was to depict not the topographical details but the fascinating play of the bright yellow morning light on architecture and water. The buildings, rendered in a hazy grey – blue, seem to float on the water like the boats. Water, sky and light are the factors that determine the picture and create its mood. There is no doubt that Turner was inspired by the lagoon city, but his real goal was Rome. Only in the 1830s and 1840s would Venice

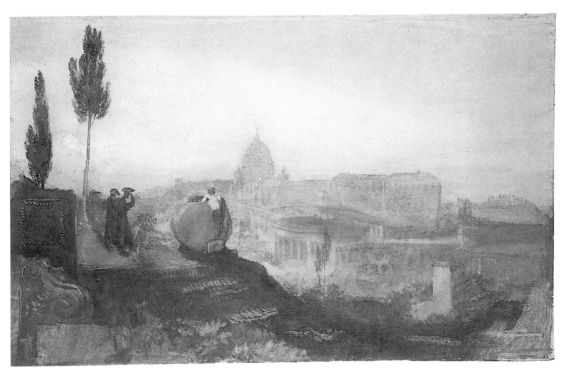

Rome: St Peter's from the Villa Barberini, 1819

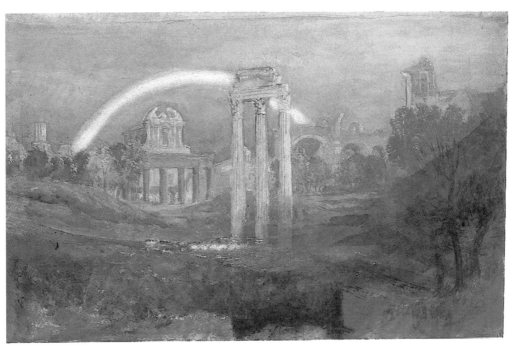

Rome: The Forum with a Rainbow, 1819

49

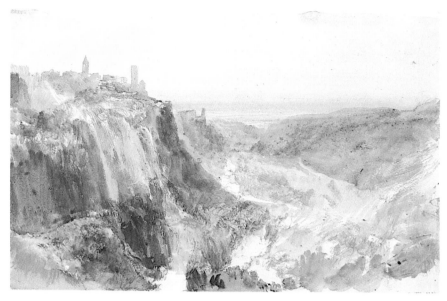

Tivoli, 1819

become his favourite subject. He traveled on via Bologna to Rimini, then
followed the coast as far as Ancona. There he turned inland and made his
way to Rome diagonally across country by way of Foligno and Narni. En
route he found himself at last in a landscape with which he was already
familiar from the pictures of Richard Wilson and Claude Lorrain. Com-
ments such as "Loretto to Recanata, color of the Hill Wilson Claude" or
"The first bit of Claude", added to his sketches, confirm this and show to
what extent his perception was marked by the works of these two artists.

He reached Rome at the end of September or beginning of October
and stayed until mid-December. There were other British artists besides
Sir Thomas Lawrence in the city, including two further members of the
Academy, Sir Francis Chantrey and John Jackson, whom Turner knew
well. However, he did not participate very actively in the social life of his
fellow countrymen. The poet Thomas Moore has a report in his diary of a
visit to the Academia Veneziana together with the famous sculptor Anto-
nio Canova and with Lawrence, Chantrey, Jackson and Turner, but such
outings seem to have been rare. In any event, Chantrey complained to Far-
ington about Turner's withdrawn and uncommunicative manner, which is
also mentioned frequently in other contexts.

With their studies of buildings, monuments, antiquities and the works
of other artists, the sketchbooks that Turner used in Rome provide lavish
evidence not only of his immense enthusiasm for his work, which left him

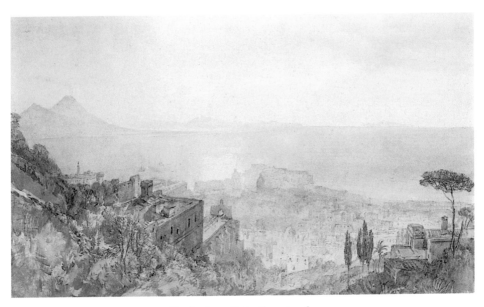

Naples from Capodimonte, 1819

little time for amusements, but also his wide range of interests. Just as he
had done in Paris in 1802, he made an intensive study of the artworks, par-
ticularly those offered by the Vatican. He devoted attention to buildings of
Antiquity such as the Colosseum, the Forum Romanum and the Pantheon
(illus.) as well as to more recent constructions such as St Peter's Cathe-
dral, both in detailed architectural studies and in distant vistas. Although
Turner's sketches of these famous buildings frequently betray the influ-
ence of Giambattista Piranesi's *Veduti di Roma* (1748–78), in such city
views as *Rome: St Peter's from the Villa Barberini* (illus.) he manages to
conjure up a new charm from subjects that had already been reproduced
hundreds of times. From a hill that rises on the left, set with ancient ruins
and figures, the viewer looks out over the massive complex of St Peter's
and the Vatican. As the leaf demonstrates, in Rome Turner had again
turned to color sketching, executed in his usual manner with pencil, water-
color and bodycolor on paper prepared with a grey ground. However, he
did not sketch in the open air but in his lodgings in the evening, a manner of
working that testifies to his great powers of imagination and his colossal
memory. He told an acquaintance in Rome that "it would take up too much
time to colour in the open air; he could make 15 or 16 pencil sketches to one
coloured".[30] While this work captures wonderfully the late afternoon
southern sun which lies over the city and makes the contours of the build-
ings hazy and diffuse, *Rome: The Forum with a Rainbow* (illus.) has a more

serious atmosphere that reflects the significance of the site. In Turner's time, the Forum was regarded as a symbol and evidence of the fall of the Roman empire. As the former center of power, its ruins were a reminder of past greatness. Over the temple of Antoninus Pius, now a Christian church, curves a rainbow, a formal means of emphasizing the idea of the finite nature of both political and religious ruling systems.

Turner made quite a few excursions into the immediate neighborhood of Rome. Now at last he could visit a place that, as we mentioned above, he had painted in 1817 as an idealized scene: Tivoli, one of Italy's most famous attractions, situated in the hills east of Rome. The building towering high above a steep ravine and the tumbling cascades combined the features of a sublime landscape with the picturesque beauty of Classical architecture. Turner, too, who filled a sketchbook here and made two color studies (illus.), was enchanted.

Following Hakewill's advice he also visited Naples, which he captured in a color sketch (illus). As at Tivoli and earlier in Venice, he dispensed with grey ground and bodycolor so that the sky, sea and coast spread out before the viewer's eyes in all their transparent brilliance, flooded with light. In the background on the left we see Vesuvius emitting a light plume of smoke. Turner, who had portrayed the volcano in action in two watercolors in 1817/18, may well have hoped that he would be able to wit-

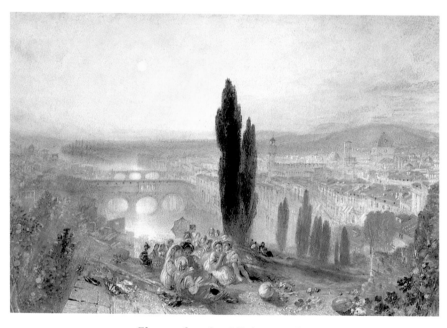

Florence, from San Miniato, ca. 1827

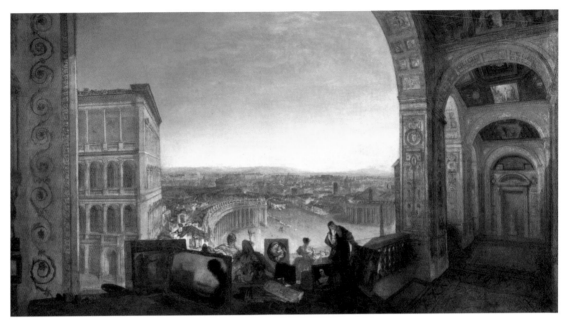

Rome from the Vatican. Raffaelle, accompanied by La Fornarina, preparing his Pictures for the Decoration of the Loggia, R.A. 1820

ness an explosion in person, especially as the volcano was fairly restless between 1817 and 1819. Unfortunately he missed the main eruption, which took place in late November when he was already back in Rome.

For his journey home Turner chose the route through Florence. The city was famed for its loveliness from the distance, and Turner too depicted it as a distant vista. He did not make any color sketches or finished watercolors of the city. Only in 1827, when he painted 25 watercolor vignettes for Samuel Rogers' poem 'Italy', did he include a view of Florence. The book, published in 1830, was so successful that Rogers commissioned Turner to illustrate his collected poems.

Turner was also able to use the material he collected on his journey for another project on Italy with which he was involved around 1827. The publisher Charles Heath, for whom Turner had been working since 1825 on *Picturesque Views of England and Wales*, his most comprehensive project of this type, was planning a book with the title Picturesque Views of Italy. Turner created three watercolors for it, including a view of Florence (illus.), but the book – announced for 1830 – never appeared as a result of the publisher's financial difficulties.

Let's go back to the year 1819. Turner spent Christmas and New Year in Florence before setting out on his homeward journey by way of Bologna,

Milan and Turin. On Mont Cenis he experienced the incident described in an earlier chapter.

By 1821 Turner had painted seven watercolors with Italian themes based on studies he had made *in situ*: four were of Rome, two of Venice and one of the Bay of Naples, while the eighth – completely out of place in this series because of its narrative drama – depicts the snowstorm he experienced during his crossing of the Alps. The Alps here are clearly seen as a dangerous obstacle, a barrier on the way to the longed-for land. These eight watercolors were bought by Walter Fawkes, who in the meantime owned nearly 80 of Turner's travel pictures, not counting those on British themes.

These works, but even more the sketchbook leaves, show that the Italian experience – the light, the color, the Mediterranean climate – had made a deep impression on Turner. If in Switzerland with its wild nature he had found an embodiment of the ideal of the sublime landscape and a satisfactory outlet for his tendency to the dramatic, Italy was the country in which he found the roots of the classic landscape painting of an artist such as Claude Lorrain. At the same time the special light and color of the Italian landscape opened up new perspectives and opportunities.

Rome was for him the center of the European cultural tradition, as he expressed in a monumental oil painting (illus.) that he produced in only two months after his return in order to exhibit it at the Royal Academy in the spring. In this picture based on numerous sketches made on the spot he presented the history, art and architecture of Rome as the cradle of European culture. The painting shows Raphael in the loggia of the Vatican, musing as he surveys his work. He is surrounded by works that underline the universality of his thinking and shown in the company of La Fornarina, who was both his lover and his model. In the middle ground we see the piazza of St Peter's with Bernini's colonnades, which however had not actually been built in Raphael's time. In the background are the Appenine Hills, hazy with the golden light that stamps the entire composition. The picture was criticized by Turner's contemporaries, not only for its architectural anachronism but also because of the unsatisfactory, confusing solution he chose for the perspective. Turner's intentions however went far beyond that of exact topographical representation and faithful depiction of a historical scene. The picture should rather be understood as an inventive, possibly somewhat overstated homage to Rome as the *caput mundi*. In addition, the simultaneous homage to Raphael had a special topicality since 1820 marked the 300th anniversary of the artist's death.

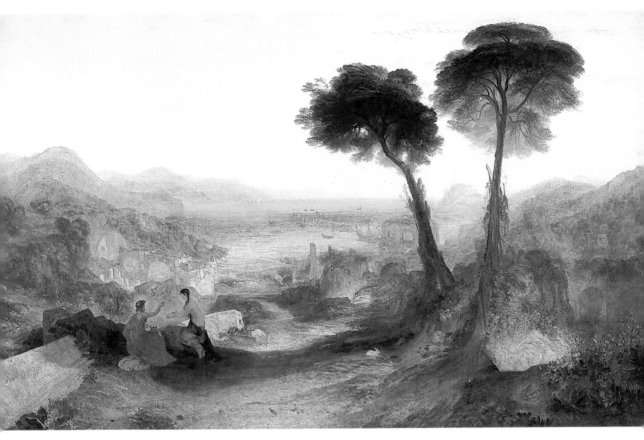

The Bay of Baiae, with Apollo and the Sibyl, R.A. 1823

A further Italian subject, which Turner exhibited at the Royal Academy in 1823, combines history painting– as a depiction of significant events from history, the present, literature and mythology– with pure landscape painting within a 'historical' landscape. *The Bay of Baiae, with Apollo and the Sibyl* (illus.) shows a coastal landscape in the style of Lorrain which associates imaginary elements with elements observed from nature. In the foreground appear the two protagonists of the Classical/ mythological scene: Apollo, who promises the sibyl as many years of life as the grains of sand she can hold in her hand. Not having requested eternal youth, she gradually disappears until nothing is left but her voice. While the sibyl is depicted with her youthful beauty still intact, the ruinous buildings in the middle ground hint at the finite nature of all existence.

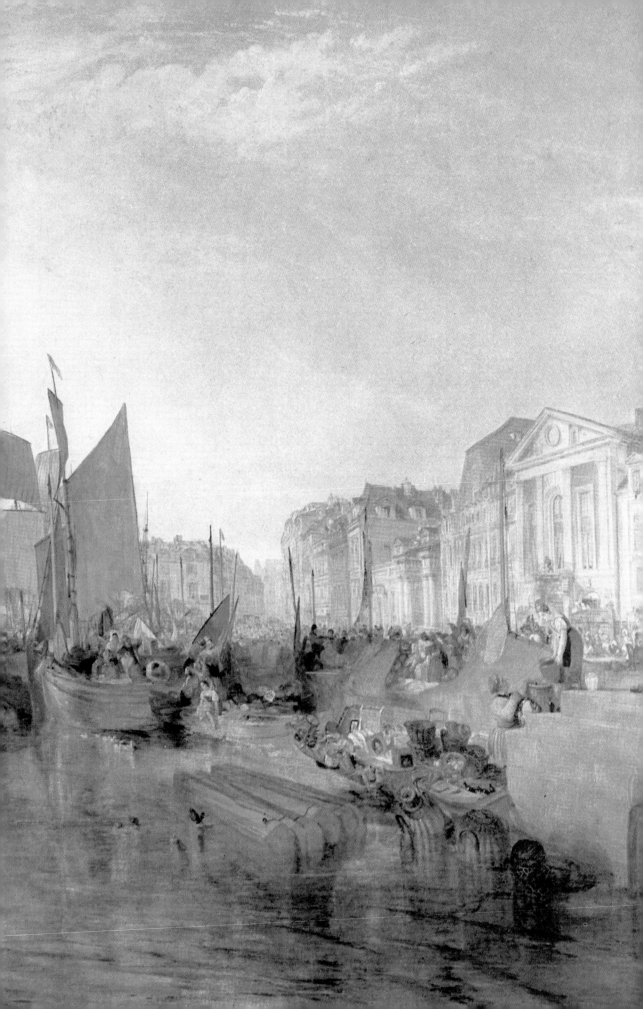

RIVERS OF EUROPE: TRAVELS BETWEEN 1821 AND 1832

"Here Turner is in his element – he revels in beauty and energy …"

In 1821, 1826, 1828, 1829 and 1832 Turner traveled in France. The frequency and the systematic way in which he carried out these trips make it probable that he had a concrete project in mind.[31]

Like Switzerland and the Rhineland, for a long time France was regarded by the English as little more than a corridor to Italy. Yet since the beginning of the century Paris had exerted something of a magnetic pull on artists. During the course of the century the Seine capital finally superseded Rome to become the main center of attraction of the 19th century.

As a result of the enthusiasm for the Gothic, attention had also begun to be paid to French architecture. Normandy attracted special interest because of its relations with England, characterized by Richard the Lionheart. The Englishman John Sell Cotman (1782–1842) knew how to play on his fellow countrymen's curiosity about their Norman heritage and worked up material collected on trips in 1817, 1818 and 1820 for his *Architectural Antiquities of Normandy*, which included 97 etchings.[32]

Detail of illustration on page 69

Dieppe, Rouen and Paris sketchbook, 1821

Turner traversed Normandy in 1821 and continued into the Ile de France, following the course of the Seine from the coast as far as Paris. He made a stop in Rouen, which had become a favoured destination for British tourists. Although the British called the town the 'French Manchester' because of its favourable location, it was its wealth of picturesque medieval architecture as well as the local dress that fascinated visitors. In his wide-format sketchbook (illus.) Turner recorded the view of the town from the river looking towards the Gothic cathedral.

His particular interest on this journey was the Seine. It is likely that he was already thinking of a large, ambitious project that however would only ever be partially realized. In 1833 the publisher Charles Heath announced a new publication, to be entitled *Great Rivers of Europe*. That same year the first part appeared as *Turner's Annual Tour – Wanderings by the Loire* with 21 engravings after drawings by Turner. In 1834 and 1835 *Turner's Annual Tour – The Seine* was published in two volumes, each with 20 engravings. All three volumes were accompanied by texts by the journalist Leitch Ritchie.[33] In format and layout they corresponded to a type of publication that had newly become fashionable: 'annuals'– in other words, yearbook anthologies – which were published in the fall for the following year and thus benefited from the Christmas trade. When the volumes illustrated by Turner appeared, Heath was already so financially overstretched that no further sequels were possible. The project had taken its lead from *The Rivers of England*, initiated by the publisher William Bernard Cooke, for which Turner had been painting watercolors since 1822. Between 1823 and 1827, 21 pages appeared, 16 of them after Turner, but then this project too was halted. A similar thing happened with the complementary publication *The Harbors of England*. With these books the publishers were reacting to the growing interest in travel on the part of an increasingly mobile public.

The Lighthouse of Marseille, as Viewed from the Sea, ca. 1828

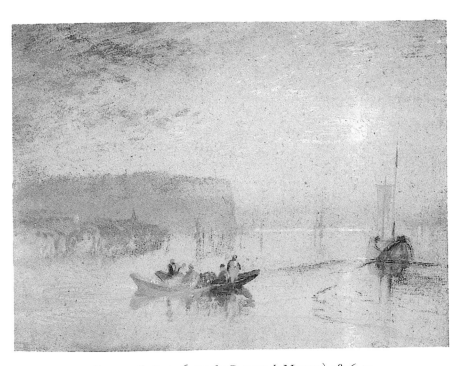

Scene on the Loire (near the Coteaux de Mauves), 1826–30

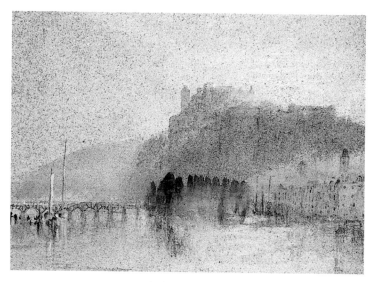

Amboise, 1826–30

Turner did not make use of his trip to France in 1821 to produce water-colors or oil paintings. His next visit to that country was in 1826. He first traveled along the coast of Normandy and Britanny to collect material for a project that was announced as The *English Channel or La Manche* but never actually materialized. He then followed the Loire from Nantes to Orleans. The plan for a series of engravings on the rivers of France must

William Miller after J.M.W. Turner,
Rouen, from St Cathrine's Hill

Paris: Marché aux Fleurs and Pont au Change, ca. 1832

have been taking concrete form by that time. The notes and sketches he amassed along the way later served as a basis for the Loire series.

In 1828 he crossed France on his way to Italy. On arrival in Paris he was still undecided – as emerges from a letter to his friend Eastlake – which route he should take to Rome; via Turin to Genoa or via Antibes. In the end he gave preference to the unknown route which took him via Paris to Orleans and from Lyons along the Rhone to Avignon and Marseilles. Once in Rome he justified his decision in a letter to George Jones: "I must see the South of France, which almost knocked me up, the heat was so intense, particularly at Nismes and Avignon; and until I got a plunge into the sea at Marseilles, I felt so weak that nothing but the change of scene kept me onwards to my distant point."[34] Possibly the idea of dedicating a series to the Rhone within the rivers project also influenced his decision.

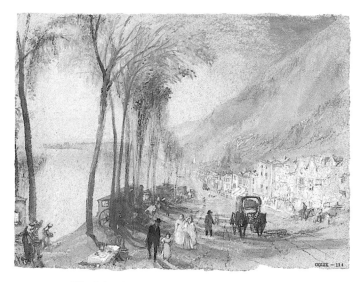

The Seine between Mantes and Vernon, ca. 1832

In 1829 Turner again investigated the course of the Seine between Honfleur and Paris. On his return journey he wandered along the coastline of Normandy as far as Saint-Malo, where he took passage to Guernsey.

A large proportion of the material for his Seine series was collected on his 1832 journey, when he again followed the river to Paris. Incidentally, the reason behind this tour was a commission of a quite different type: Turner was to provide illustrations for Walter Scott's *Life of Napoleon*.

The dating of the 61 watercolors which Turner created as designs for engravings for the two rivers series as well as of the other works painted in this connection is uncertain. The works relating to the Loire must have been produced between 1826 and 1830, while the Seine series must be dated immediately around the trip undertaken in 1832. All the works are around 14 x 19 cm in dimensions and painted on blue paper. This was an innovation in which Turner showed a wonderful reaction to the subject matter, and he intensified the effect even further for the Moselle series. The blue ground permitted him to be extremely economical in portraying the water and sky; however, like the technique of painting with oils on a dark background, it necessitated the use of an opaque medium as bodycolor. Turner added structures and details with a pen, creating enchanting and effective contrasts between drawing and painting.

His free handling of watercolor and bodycolor made great demands of the engraver. Details were only hinted at vaguely and were probably settled with Turner's help during work on the steel plates. The subtle light and

weather conditions which give the watercolors their great charm were also difficult to transpose into an engraving.

In addition to urban views of Nantes, Orleans and Tours the Loire series contains two pure riverscapes – unusual in a topographical series. This gave Ritchie the opportunity to turn his attention to Turner's artistic achievements rather than provide local information: "Here Turner is in his element – he revels in beauty and energy; and if, to those who have grown cold in their soul and their imagination, his pictures appear to lack mathematical precision, they are identified with their model in a single fleeting glance by all those who are capable of sensing genius, and who see more in nature than its external and touchable forms."[35] Ritchie thereby clearly rebutted the stubborn supporters of exact topographical illustration and acknowledged Turner's innovative achievements in the genre of the travel picture; it is not the topographical but the imaginative qualities that come to the fore. Whereas a leaf like *Scene on the Loire* (illus.) is completely given over to the play of light on the river landscape, in other works Turner depicts the famous chateaux, for example Amboise (illus.), which are scattered along the river. Just like the castles on the Rhine they are here inserted into the scene as important components of the 'picturesque view'. As with the Rhine series, for his Loire series Turner frequently picked a viewpoint

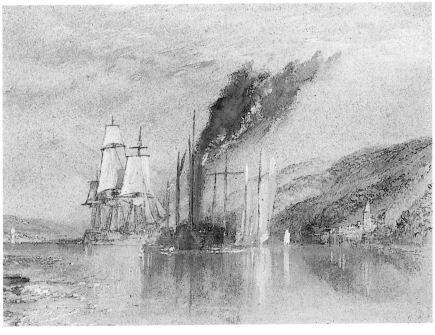

Between Quilleboeuf and Villequier, ca. 1832

in the center of the river. The sights seem to glide past the viewer, who feels as though he is on a moving boat. This impression is intensified by Turner's style of painting, which lends dynamism to the formerly static travel picture; the viewer is drawn into the picture, and the movement of the traveler is visualized as a continual process. The journey itself becomes the theme of the landscape.[36] On other pages, the interest that Turner brings to bear on buildings is evidence of his training as an architectural draftsman, while his depiction of everyday life along the river and in the towns reflects his constant endeavour to link people into their surroundings.

The 40 works for the Seine series present a versatile palette of compositional solutions and moods that was bound up not only with Turner's deep knowledge of this river but also with its importance for transport and as a scenically enchanting river. In contrast to the Loire series, here Turner frequently chooses panoramic views from the hills down over the wide river landscape, such as *Rouen, from St Cathrine's Hill* (illus.), which was later engraved by William Miller after Turner's design. Rouen, which was also painted many times by the British artists John Sell Cotman, Richard Parkes Bonington, Thomas Shotter Boys and David Cox, was allocated four pages by Turner, while the Seine capital Paris (illus.) was accorded pride of place in the series with five views. A cheerful holiday mood reflecting Turner's enjoyment of travel and his pleasure at being on the road emanates from *The Seine between Mantes and Vernon* (illus.). A road flanked by houses in sunlight runs right alongside the riverbank scattered with trees. A carriage is approaching, while in the left foreground a table is laid, an invitation to a celebration. Here too, as with the Loire river scenes, the landscape is presented from the traveler's perspective. "The static image of a view presented directly before the viewer… is dispensed with in favour of movement suggesting the process of travel."[37]

This is also the sense in which we should understand a leaf such as *Between Quilleboeuf and Villequier* (illus.). Here the river, which Turner characterizes as a lively, economically important highway, is shown between two places. In the center a steamboat, a symbol of the luxury and convenience of modern life, is contrasted with sailing ships representing a Romantic nostalgia for days gone by.

Apart from works on paper, Turner's trips to France also resulted in a few oil paintings. In 1829 he exhibited at the Royal Academy a picture entitled *The Banks of the Loire*, now lost. The following year he showed *Calais*

Mouth of the Seine, Quilleboeuf, R.A. 1833

Sands, Low Water, 'Poissards' Collecting Bait, which is based on a study sketched in 1826. The wide, peaceful landscape with the women working is indebted to Bonington's French coastal scenes, and could hardly present a greater contrast to Turner's *Calais Pier*, which he had painted 26 years earlier. Finally, in 1833 Turner showed at the Academy the oil painting *Mouth of the Seine, Quilleboeuf* (illus.). This was based on a watercolor for the Seine series, but Turner altered the form and color of the composition in order to enhance the dramatic effect. In the exhibition catalog he commented as follows: "This estuary is so dangerous from its quicksands, that any taking the ground is liable to be stranded and overwhelmed by the

Sketch maps of the Meuse between
Moschkern and Starkenburg, 1824

rising tide, which rushes in in one wave."[38] The danger here is not just indicated by the spray leaping off the waves but also by the coloring of the treacherous water, which ranges from a dark grey-black to a luminous orange-red. Turner also gives a symbolic warning of lurking danger through the combination of lighthouse and cemetery in the background. Although the small-format work from the series is a purely topographical illustration, here Turner gives the subject the weight of a generally valid symbol.

His involvement with French subjects was not yet over. Two journeys to the Meuse in 1824 and 1839, discussed below, permitted him to explore a new region of the country. On his late trips to Switzerland he crossed France several more times, although no important works resulted. Finally, a last short trip to the Continent in 1845 took Turner to Dieppe and the coast of Picardy.

Turners' investigation of these two further river landscapes must be considered within the context of his *Rivers of Europe* project. The 1824 trip not only took him to France and the Meuse but also, for a second time, to Germany, where he explored the Moselle. The first part of the *Rivers of England* series had appeared on the market the previous year, and the thought of a sequel involving other rivers must have motivated him to undertake this journey. He would certainly have seen the topicality of the idea confirmed in such publications as William Wordsworth's *Memorials*

Rivers Meuse and Moselle sketchbook, 1824

of a Tour on the Continent, 1820, which appeared in 1822 and in which the section of the Meuse between Liège and Namur is described, or Robert Batty's *Scenery of the Rhine, Belgium and Holland*, which at the same time aroused his curiosity about territory as yet unknown to him.

For a long time this trip was dated to 1826, but it has now proved possible to correct this error in the light of Turner's own notes in his sketchbooks.[39] Turner used four sketchbooks, in which he recorded the particular section of the journey (illus.) and his timetable as well as innumerable landscape studies. He extracted important information about the Moselle from Alois Schreiber's *The Traveller's Guide down the Rhine*, an English edition of which had appeared in 1818.

Turner left London on 10 August; from Calais he traveled via Brussels to Liège. He then followed the Meuse upstream as far as Verdun by means of horse-drawn boats. He was mainly impressed along the way by towns such as Huy, Namur and Dinant, dominated by huge fortresses. From Verdun he turned east, traveling by carriage to the French section of the Moselle, which he followed from Metz north to Thionville. He made a detour to Luxembourg before joining the Moselle again at Trier, the start of the river's most famous stretch up to where it finally enters the Rhine at Koblenz.

Even if initially it was the Rhine on which English travelers lavished their greatest attention, in the 1820s a gradual enthusiasm for the Moselle

also developed, although this was not made easy by the poor transport conditions, which were only improved in the 1830s.[40] In accordance with the esthetic theories of the time, the Rhine landscape with its steep cliffs and dark ruins was felt to embody the Sublime, whereas it was more the picturesque charm of the Moselle that was appreciated, with castles and innumerable villages and their churches nestling amid its gentle, vine-covered hills. The writer Fanny Burney had traveled through the region in 1815 and described the differences between the two landscapes: the Rhine possesses "the radiant glory of historical symbolism", while the Moselle enchants with its "original, unspoilt and picturesque charm".[41] In 1839 Baedeker stated: "The Rhine is more magnificent, the Moselle more romantic."[42]

Turner too fell under the spell of this landscape, and once he reached Trier he even began to work in color. For the first time he had brought along so-called 'roll' sketchbooks, which had a soft leather cover and could be rolled up and carried easily in the coat pocket. He recorded sundry river views with watercolor and bodycolor on grey-washed paper, traveling by boat as far as Koblenz. Because of his tight schedule he had hardly any opportunities to investigate the villages and hills more closely, so he recorded the particular stretch from the river in small panoramic sketches, adding the names of the villages and occasionally noting down compass readings (illus.). After two days' stay in Koblenz he must have traveled the stretch back to Cologne with pleasure. There he left river landscapes behind and returned by way of Belgium to the French coast, making an excursion to Dieppe, which he had already visited in 1821. In mid-September he arrived back in London after a tour lasting five weeks.

He did not produce any watercolors or oil paintings on these rivers after his return. In connection with his rivers project he concentrated for the next few years on the Loire and the Seine and only returned to the Meuse and Moselle in 1839. However, one result from the first journey is an oil painting with a French theme that Turner may have been commissioned to paint by the collector John Broadhurst before his departure; he exhibited it at the Royal Academy in 1825. It shows a view of the *Harbor of Dieppe* (illus.) and is based on sketches that he made during his visit there. More important to Turner than the topography of the town, with the dome and tower of St Jacques in the background, is the harbor with its ships and bustling activity, a scene which reflects his own experiences on various rivers.

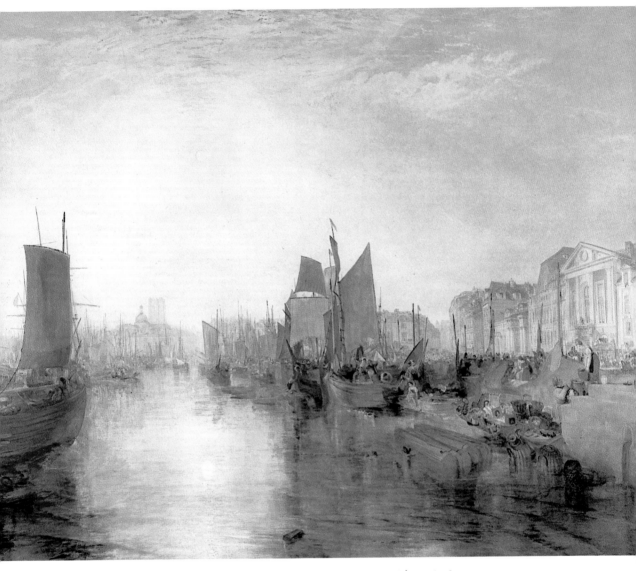

Harbor of Dieppe (Changement of Domicile), R.A. 1825

At the end of August 1825 Turner set out on a trip to the Netherlands, his second after that of 1817.[43] He traveled from Dover to Rotterdam, then – as in 1817 – on to Amsterdam, and via Utrecht and Maastricht to Cologne, where he made careful sketches. He then took the familiar route back to Ostend via Aachen, Liège, Antwerp, Ghent and Bruges, and thence to Dover. As was his custom, he recorded even these well-known places again in his sketchbooks to ensure that he did not miss any changes and to pad out his collection of material with further details.

69

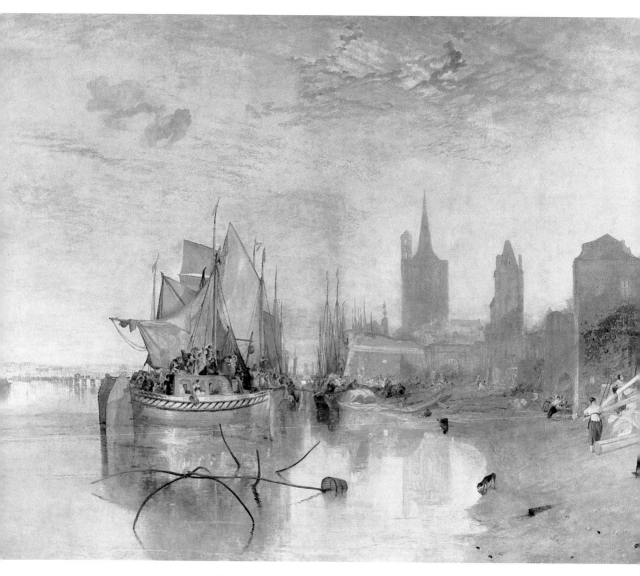

Cologne, The Arrival of a Packet Boat, Evening, R.A. 1826

Probably Broadhurst had commissioned a pendant to *Dieppe*, which made the trip necessary.[44] Turner's route and his intensive study of Rotterdam and Amsterdam make it likely that he was seeking a Dutch theme. However, after his return he painted a picture of the Rhine at Cologne based on his most recent sketches: *Cologne, the Arrival of a Packet Boat, Evening* (illus.). Exhibited at the Royal Academy in 1826, this was in fact bought by Broadhurst. As with *Dort, or Dordrecht, the Dort Packet Boat from Rotterdam Becalmed*, resulting from his first trip to Holland and exhibited

70

in 1818, and *Dieppe*, the artist's focus is on what is happening on and around the boats. Turner leaves out the famous cathedral and shows the riverbank with its bulwark dating from the 16th century and the church of Great St Martin. Whereas in *Dieppe* the sun is high in the sky, in *Cologne* it is setting: a reddish-gold veil of color pervades the scene. In a manner typical of his work, Turner here combines elements of Dutch marine painting, against whose exponents he was keen to measure himself, with the standard of classical landscape painting according to the model of Claude Lorrain, further enriched by the topographical aspect and enhanced by the visionary, brilliant light and color effects.

Not until 1827 did Turner paint two pictures with Dutch themes and exhibit them at the Royal Academy: *Rembrandt's Daughter* and *Port Ruysdael*, both by way of homage to the two masters whom he revered. Before his oil painting *Ostend* of 1844 he also produced any number of paintings which are either related stylistically to the Dutch masters of the 17th century or are dedicated to the country's history and topography.[45]

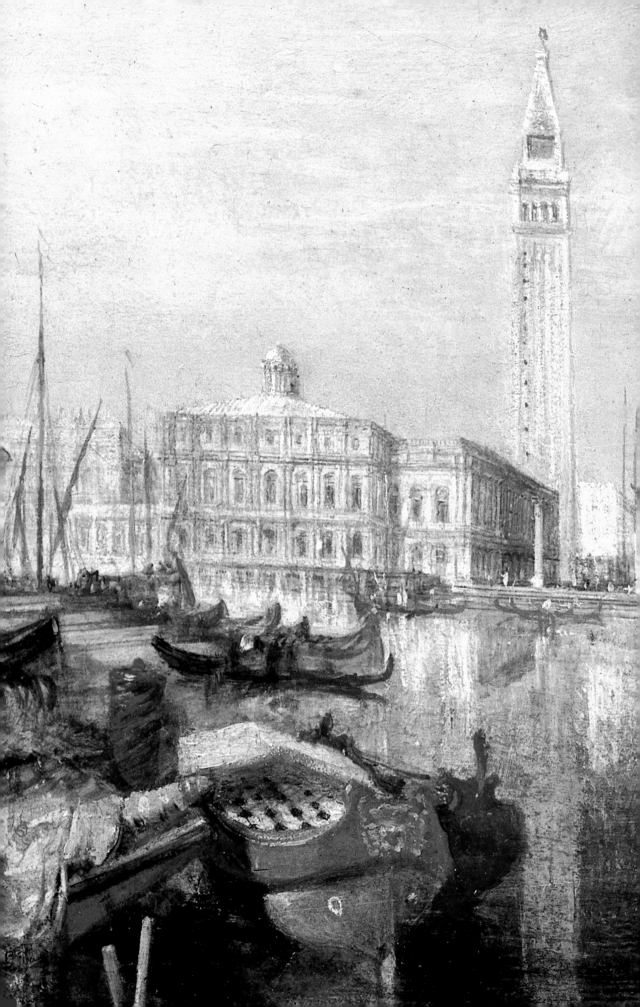

ITALY, 1828 AND 1833: ROME AND VENICE

"Two months nearly in getting to this Terra Pictura, and at work."

In 1828 Turner was busy with work for Rogers' poem 'Italy' and with engraving designs for the series *Picturesque Views of Italy*, planned by Charles Heath but never actually carried out. It is thus obvious why he should decide to set off again for Italy. This trip was to be completely different from the first.[46] Whereas in 1819 he had filled 23 sketchbooks with innumerable studies within a six-month period, on this second trip he used only ten sketchbooks within the same period of time, eight of which he used en route. Naturally he recorded places both well-known and new to him in more or less carefully executed sketches, but his main interest was Rome, where he intended to move into a studio on the Piazza Mignanelli with his friend Charles Eastlake in order to paint in oils.

The first part of Turner's route has already been described. The desire to see the south of France may certainly also have had its roots in the region's Roman past, which was still visible in a number of monuments and the study of which Turner saw as suitable preparation for his stay in

Detail of illustration on page 79

Rome. From France he traveled along the coast to Genoa, a stretch that had only become passable by carriage since the 1820s.

In the above-mentioned letter to George Jones of 13 October Turner gave his opinion of this stretch of road: "Genoa and all the sea-coast from Nice to Spezzia is remarkably rugged and fine."[47] He made numerous sketches, which he later used as the basis for watercolors. As far as Livorno he traveled by boat, then continued to Florence by way of Pisa and thence to Rome, from where he wrote to Jones: "Two months nearly in getting to this Terra Pictura, and at work."[48] He stayed in Rome for nearly three months. As we know from Eastlake's letters,

View of Orvieto, painted in Rome, 1828, R.A. 1830

Southern Landscape with an Aqueduct and Waterfall, 1828

during this period Turner finished three pictures and began work on several oil studies. In an exhibition in December which attracted more than 1000 visitors, Turner presented the three finished works, *View of Orvieto, Painted in Rome, Regulus* and *The Vision of Medea*. Eastlake reports the effect of this exhibition: "The foreign artists who went to see them could make nothing of them. Turner's economy and ingenuity were apparent in his mode of framing those pictures. He nailed a rope round the edges of each, and painted it with yellow ochre in tempera. ...You may imagine how astonished, enraged or delighted the different schools of artists were, at seeing things with methods so new, so daring, and excellencies so unequivocal. The angry critics have, I believe, talked most..."[49] Turner's diffuse painting style met with a lack of understanding, especially from German and Austrian artists who were concerned to achieve a detailed, smooth technique. The harshest judgment was probably that of the landscape painter Joseph Anton Koch with the phrase "Daubed is not painted".[50]

The *View of Orvieto* (illus.), which Turner later reworked before presenting it at the Royal Academy, has in its foreground a genre scene: two women are doing their washing in a stone sarcophagus – a reference to

Childe Harold's Pilgrimage – Italy, R.A. 1832

the pragmatic way in which the contemporary inhabitants dealt with the remnants of an ancient culture. By including the word 'view' in the title Turner emphasizes the topographical character of the painting, which is based on a brief sketch recording his first sight of Orvieto. Despite numerous studies it was this '*prima vista*' that he finally rendered in oils. Reminiscent of Claudean compositions but also of his own *The Bay of Baiae*, the picture is simpler and clearer in structure and evokes the magic of the southern atmosphere without the distraction of mythological ballast. The painting manner is very sketchy and gives the impression the picture was rapidly painted in the open air, but this was not how Turner worked. His Roman oil sketches, for example *Southern Landscape with an Aqueduct and Waterfall* (illus.), are compositional studies painted in the studio which incorporate sketches based on the actual topography to form ideal landscapes celebrating the Mediterranean. Here Turner combined architectural elements that he had seen in the region of Nepi with a waterfall reminiscent of Tivoli.

The two other oil paintings exhibited in Rome do not relate to the southern landscape but are based on historical or mythological themes with dramatic content, whereby the artist intended to underline the breadth of his repertoire.

At the beginning of January Turner started back on his homeward journey. He took the route he already knew via Foligno, Ancona, Modena and Milan and then in the Alps found himself in the predicament already described.

His original intention had been to return to Rome the following year, which is why he left a few unfinished paintings with Eastlake, but he never made that journey. The health of his father, who died in September 1829, prohibited a longer stay abroad, and in 1830 it was not advisable to travel on the Continent as a result of the political unrest in Belgium and France. Although Turner was never again to see the south of Italy, in later years he devoted any number of mythological and historical scenes to it, fed by his fund of sketches and memories of his experiences in Italy.

His preoccupation with Claude Lorrain also continued into the 1830s, as the oil painting *Childe Harold's Pilgrimage – Italy* (illus.), exhibited in 1832, demonstrates; however, it goes far beyond his predecessor in terms of coloring and manner. Turner here varies the Claudean scheme in a way

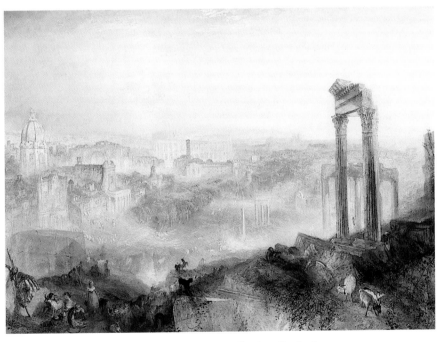

Modern Rome – Campo Vaccino, R.A. 1839

Clarkson Stanfield (1793-1867),
Venice from the Dogana, R.A.1833

that had already been announced in his Roman compositional studies: draw-
ing on his own observations from various souces, he compiles an ideal
landscape. But Italy was not just the land of Claude Lorrain; it was also
that of Byron, who had put into words his image of Italy in Canto IV of
'Childe Harold's Pilgrimage'. Turner translated Byron's message into his
own 'language' as homage simultaneously to the poet and to the country
and underlined this when he presented his painting at the Royal Academy
with lines loosely based on the poet's: "Italy, still lovely since that time,
you are the garden of this world, the cathedral ... What can equal you, even
in your decline? Your very weeds are beautiful, your wreck a glory."[51]

Canaletto (1697–1768), Venedig: Die Bacino di S. Marco an Himmelfahrt,
um 1732

Bridge of Sighs, Ducal Palace and Customhouse, Venice:
Canaletti [sic] Painting, R.A. 1833

Byron, in his original lines, was lauding the simultaneous beauty and decay of the country, a romantic point of view that Turner shared. The contrast between ancient and modern civilizations, between former greatness and present decline, was a theme that struck a broad chord in England in the 1820s and 1830s and had a special topicality in view of the military campaigns and Napoleon's defeat. Turner accordingly developed ideas for pairs of pictures that compared the past and present of Italy and Rome. In 1838 he painted *Ancient Italy – Ovid is Banned from Rome and Modern Italy – the Pifferari*, and in the following year *Ancient Rome – Agrippina Lands with Germanicus' Ashes. The Bridge of Triumph and the Restored Palace of the Caesars and Modern Rome – Campo Vaccino* (illus.). Anything but a glorification of times past, both *Ancient Italy* and *Ancient Rome* depict the decline of the Roman empire. Ovid's banishment is a reference to a repressive, corrupt society, whereas the modern Pifferari stand for a simple but more natural, less spoilt culture. Similarly with the other pair, Germanicus died under mysterious circumstances, probably poisoned by his uncle, the emperor Tiberius. *Modern Rome* gives a view of the city in Turner's time, presenting itself in undiminished beauty, even if the ruinous Forum –

Tavern scene in Linz on the Danube, 1833

Two views of Innsbruck,
Vienna to Venice sketchbook, 1833

Venice: The Piazzetta and St Mark's, Night, ca. 1833-35

once the center of power– has been taken over by nature and now serves only as a cow pasture. The magical atmosphere that emanates from the painting is based essentially on the diffuse, delicate coloring, which throws a transparent shimmer over the entire picture.

At the beginning of the 1830s Turner returned to his intensive study of Byron. In 1833 we find him following the poet's path en route to Venice.[52] The preoccupation with Byron's work had taken on a new dimension since his death in 1824. Canto IV, with which Byron had made Venice a 'Romantic marker',[53] enjoyed particular popularity. The rise in tourism had caused alterations in the urban infrastructure: old palaces were being converted into modern hotels. Turner, for example, stayed at the Hotel Europa, the former Palazzo Giustiniani, during his second visit. Six theaters entertained the public every evening in the summer. At the same time there was an increased demand for Venetian themes, and artists such as Samuel Prout, who visited Venice for the first time in 1824, or Richard

The Bridge of Sighs: Night, ca. 1833–35

Parkes Bonington, who followed in 1826, responded with watercolors and oil paintings. Clarkson Stanfield showed his *Venice from the Dogana* (illus.) at the Royal Academy in 1833. Turner had also shown a Venetian theme, even before his journey: *Bridge of Sighs, Ducal Palace and Custom-house, Venice: Canaletti [sic] Painting* (illus.). Undoubtedly no coincidence, even if the rumor that Turner painted the picture in two or three days in a kind of personal contest with Stanfield is certainly apocryphal. The two artists repeatedly devoted themselves to the same groups of subjects. The previous year Turner had already handled a Venetian theme when he painted a watercolor with a view of the Rialto Bridge in the moonlight for Rogers' Poems. Both Stanfield's and Turner's pictures were influenced to a considerable degree by Canaletto (1697–1768). The latter's topographical panoramas (illus.) had met with a rapturous response in England, where the artist had lived for some time, and even in the 19th century were still extremely popular. Turner brings the esteemed master himself into the picture, paying him homage in theme and composition, without however following him totally as regards manner and coloring. The final impetus for Turner's journey was given by the prospect of a commission.

In San Marco: Views from the Venice sketchbook, 1833

The Lovers: a Scene from Shakespeare's
The Merchant of Venice

H.A.J. Munro of Novar, whom he got to know in about 1826 and who first purchased one of his pictures around 1830, wanted a watercolor with a view of Venice. Business-minded as he was, Turner insisted that Munro finance the trip, or at least that is what Walter Thornbury, Turner's first biographer, reports.[54]

Turner chose a different route from the one he had followed on his first visit, taking him through southern Germany to Vienna, as has been only very recently proved possible to reconstruct.[55] Samuel Prout's Facsimiles of Sketches Made in Flanders and Germany, which had just appeared, may well have influenced this decision. Instead of traveling through France, Turner went via Belgium – after a short detour to the Meuse – to the Middle Rhine and followed the river, probably some of the way by steamboat, from Cologne to Mannheim. From this point he not only encountered new and important towns but also new river landscapes, doubtless always with his large rivers project in mind. From Mannheim he traveled along the Neckar, making his first visit to Heidelberg– already highly popular with tourists– which he recorded in a number of sketches. By way of Heilbronn and Stuttgart he arrived in Munich, where he stayed a while, since the city had a number of novelties to offer as a result of King Ludwig I's building activities. The Glyptothek, by the architect Leo von Klenze (1784–1864), had just been completed, while the Pinakothek was under construction: Turner recorded both in his sketchbooks. Instead of taking the boat to Vienna, as was customary at that time, Turner continued overland in order to see Salzburg, which was particularly praised by English travelers. He then went on to Linz, where he sketched the interior of a guesthouse (illus.) that reminded him of the work of the Dutch painter Pieter de Hooch (1629–1677). In Linz he finally got into a boat and traveled down the Danube to Vienna. In exploring this river Turner was ahead of his time. Travelers showed little interest in the Danube landscape; only in the 1840s– after the introduction of a steamboat service in 1837– did its wild, dark scenery begin to be investigated and appreciated. But, however much of a pioneer Turner may have been, he did not convert the material he had collected into watercolors or oil paintings. Once he reached Vienna he sketched relatively little but was obviously highly interested in the imperial art collection. He returned by land to Salzburg and continued to Innsbruck (illus.). As can be deduced from the announcements in the local newspapers, he finally reached Venice on 9 September. However, he did not stay there for more than a week.

Juliet and Her Nurse, R.A. 1836

A group of some 30 color works in watercolor and bodycolor on brown paper were probably produced between 1833 and 1835 as a result of this second visit. They contrast strongly with Turner's later views of Venice, which show the city from the water in sparkling daylight. Because of the color of the paper the majority of these are night scenes with interesting, dramatic light effects, 'close-ups' of narrow canals or interiors, such as of a theater, which often cannot be identified and were executed in a very sketchy manner. Two of the works show better-known subjects. One is of the Piazzetta looking towards St Mark's (illus.), in which the night-time atmosphere is achieved with blue and brown tones on the colored ground and enlivened in a ghostly manner through chiaroscuro contrasts. The figures clothed in red in the foreground set a special accent. The other (illus.)

depicts the Bridge of Sighs, seen close to from the canal, in a few lines and patches of color; a couple of bright stars glitter in the sky over the somber scene.

In this series, as he had already done in his view of the Rialto Bridge by moonlight for Rogers' Poems, Turner seems to have anticipated the theory, soon to become very popular, that "Venice is a city that should really only be seen by moonshine", as Eduard von Bülow remarked in his travel sketches of 1845/46.[56] Around the turn of the century the Queen of the Seas appeared in travel pictures as the 'Queen of the Night', and the painter Friedrich Nerly's views of Venice, produced after 1837, were so much to the public taste that he had to repeat his *Piazzetta by Moonshine* more than 30 times.[57]

Turner did not turn his studies into sellable watercolors, but some of the leaves that show fireworks, theater scenes or rooftop vistas appear to have some connection with the oil painting *Juliet and her Nurse* (illus.), which was exhibited in 1836. Possibly Turner saw Shakespeare's play *Romeo and Juliet* in one of Venice's theaters while he was there, and it was this that gave him the idea for the picture.

Despite his plans, he did not produce a watercolor for Munro but an oil painting, which he presented at the Royal Academy in 1835. The previous year, shortly after returning from his trip, he had exhibited an oil painting which he had executed on commission for another collector. These two paintings of Venice are topographical portrayals but *Juliet and her Nurse*, which was also purchased by Munro, has an extra dimension. The picture caused a huge stir, not only on the grounds of form but also because of Turner's liberty with the historical event, which he moved from Verona to Venice. A critic wrote in *Blackwood's Magazine:* "It is neither sunlight, moonlight, nor star-light, nor fire-light … Amidst so many absurdities, we scarcely stop to ask why Juliet and her nurse should be at Venice. For the scene is a composition as from models of different parts of Venice, thrown higgledy-piggledy together, streaked blue and pink, and thrown into a flour tub."[58] As a result of this scornful judgment the then 17-year-old John Ruskin (1819–1900) felt compelled to compose a defence of Turner which, however, at the latter's request, was not published. Nevertheless, the article formed the basis for the five volumes of *Modern Painters* (1843–60) in which Ruskin set out his passionate admiration for Turner's art. When the picture was engraved in 1842, Turner changed its title to *St Mark's Square, Venice (Moonshine)* and added a line from Byron's

Canto IV. Obviously, the criticism had forced him to specify the time of day and to relinquish the reference to Shakespeare's *Romeo and Juliet* in favour of a general statement emphasizing the city's festive, entertaining and romantic character.

Before Turner returned to Venice in the summer of 1840 for what would be the last time, he exhibited three more pictures with Venetian themes at the Royal Academy. The one shown in 1837, with two lines from *The Merchant of Venice*, also relates to Shakespeare, whose work– in addition to Byron's– played a considerable role in fuelling the enthusiasm for Venice, especially in the 19th century. One of the other two pictures presented in the spring of 1840 is of the Bridge of Sighs. In the catalog Turner quotes the initial lines of Byron's Canto IV– not quite literally, as given in an earlier chapter, but close enough in meaning: "I stood on a bridge, a palace and a prison on either side."[59]

Travels on the Continent, 1835 to 1839

"I would like to go to Berlin"

In 1835 Turner made a trip that – like that of 1833 – took him to regions and cities that were not on the traditional Grand Tour but whose beauties had already been discovered by the tourists of the new era. Thus, although the artist did not actually step onto what one might call new territory, the unusual pattern of his journey demonstrates his curiosity and his untiring search for new impressions: he was, after all, sixty years old. This was one of the most private and personal of all his journeys, especially as only a single watercolor resulted from it, and his impressions are reflected solely in the pencil studies in the six sketchbooks he used.[60]

He started out from London at the end of August, following a route that would soon become established in Murray's *Handbook for Northern Germany*. After almost two days on a steamship he reached Hamburg. This important trading center was of great interest to Turner – we should remember his preference for harbor towns – and was appreciated by the English for its similarity to London and its liberal, cosmopolitan atmosphere.

Detail of illustration on page 91

Dresden and Berlin sketchbook, Berlin: the Brandenburg Gate, 1835

Instead of continuing straight to Berlin, Turner made a detour across
the Baltic to the Danish capital Copenhagen, where, in addition to the
royal palaces, he sketched the church of Our Lady with plaster versions of
the Apostle figures by Bertel Thorvaldsen (1768–1844). Turner certainly
knew the famous Danish sculptor, who spent the majority of his life in
Rome, from his previous visit there and was curious to study his work in
the setting of this Neo-classical building. He continued, probably by
packet-boat, to Stettin and thence by coach to Berlin. Along the way he
compiled a small dictionary with phrases such as "Ich möchte nach Berlin
fahren" (I would like to go to Berlin), probably with the assistance of a
fellow traveler. Once in the German capital he tirelessly sketched the
many intriguing buildings, from the Stadtschloß by Andreas Schlüter

*Dresden and Berlin sketchbook, Dresden: the Frauenkirche
from the New Market, with the Johanneum on the left, 1835*

Snowstorm, Avalanche and Inundation – a Scene in the Upper Part of Val d'Aout, Piedmont, R.A. 1837

(1660–1714) to the Brandenburg Gate (illus.) by Carl Gotthard Langhans (1732–1808), and Karl Friedrich Schinkel's buildings, which had left their decisive mark on the city.

Turner continued to Dresden, already known as the 'Florence of the Elbe' because of its beauty. In innumerable sketches he focussed not just on such well-known edifices as the church of Our Lady (illus.) and the Zwinger and views of the river, but also on the collection of paintings started by Augustus III. Turner took a side trip into 'Saxon Switzerland' with its steep rock walls and bizarre stone formations that tower high above the Elbe (illus.). Even at that time the area was highly popular and easily accessible for tourists. Turner would have heard about it from his friend Augustus Wall Calcott, who had made a similar trip in 1827, but also from a publication, Captain Robert Batty's *Hanoverian and Saxon Scenery*, which had appeared in 1826–29. Turner's route took him on to Prague, where he was particularly fascinated by the panoramic vistas

On the Moselle, 1839

over the city from various viewpoints (illus.). His colleague and friend David Wilkie had visited Prague in 1826 and described it as a place "where our friends, Callcott and Turner, would be able to find excellent subjects for their work: a romantic and picturesque city in the highest degree."[61]

As Turner's sketchbooks and as announcements in the local newspapers testify, he returned via Nuremberg and Frankfurt am Main. In Mainz, where he would certainly have taken the steamboat down the Rhine as far as Cologne, he found himself back on familiar ground. The last stretch, however, was new to him as, instead of traveling across country as usual to Calais or Ostend in Belgium, he used the most modern, rapid transport connection and continued down the Rhine to Rotterdam, from where he made the crossing to England after a journey that had lasted almost six weeks.

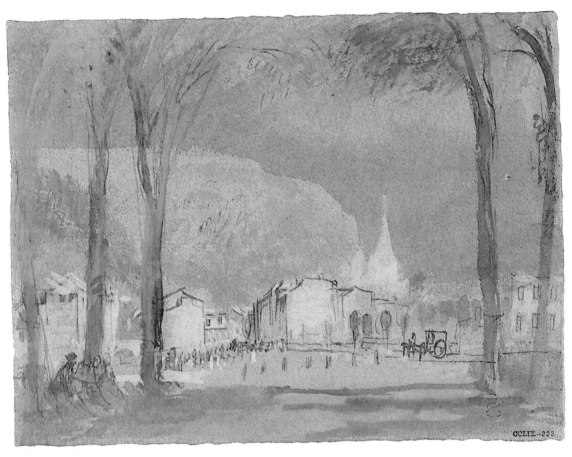

The Place Royale, Spa, from the Entrance to the "Promenade de Sept-Heures", ca. 1839

In 1836, the year after this intensive city tour, Turner turned back to nature. After 34 years he again wished to visit a landscape that had had a decisive influence on his art: Switzerland.[62] Completely contrary to his usual custom, this time he did not travel on his own but asked his friend and collector Munro of Novar to accompany him. Munro was an enthusiastic art lover and amateur artist, and Ruskin later reported the almost wordless lessons that Turner gave his friend en route. Through Munro we know that Turner began to work in color in Switzerland, but it is difficult today to identify the individual leaves, which were originally bound into a sketchbook but were later separated out and mixed with leaves from other sketchbooks.

However, the oil painting *Snowstorm, Avalanche and Inundation – a Scene in the Upper Part of Val d'Aout, Piedmont* (illus.) which resulted from the journey, and which Turner presented at the Royal Academy in 1837,

marks a return to the dramatic element of the Sublime. With this picture – inspired by the landscape of the Aosta valley if not by his own experiences – Turner goes back to two works of 1810 and 1812: *The Fall of an Avalanche in the Grisons* and *Snowstorm: Hannibal and his Army Crossing the Alps.* He combines these two catastrophes of nature into a single, apocalyptic event, the drama of which is heightened still further by the flood. The world seems to dissolve into a huge, swirling vortex, which the artist had already used as a compositional tool in the Hannibal picture in order better to visualize the imminent cataclysm. This vision of the power of nature over human life stands in stark contrast to the classically beautiful land-scapes in the tradition of Claude Lorrain which Turner was also painting at that time.

In 1839 Turner planned another trip to Germany by way of Belgium and France. Perhaps he was still thinking about his enormous *Rivers of Europe*

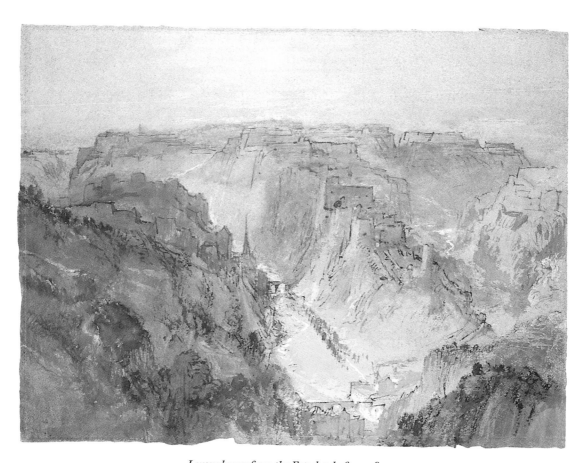

Luxembourg from the Fetschenhof, ca. 1839

Distant View of Cochem, ca. 1839

project, since he followed the course of the Meuse and Moselle, as in 1824.[63]
The visit to Germany was not only a sign of his undiminished interest in
that country, it also reflected a general trend. Murray's first two hand-
books on northern and southern Germany had appeared in 1836 and 1837,
and Rhine subjects were particularly popular at art exhibitions held in
those years. However, the real motivation behind the 1839 journey was
a book published the previous year, *Sketches on the Moselle, the Rhine & the
Meuse* by Clarkson Stanfield, the artist with whom Turner had already
clashed regarding the similarity of their Venetian subjects. But Turner
used his colleague's views as guidelines, and in the end Stanfield lent him a
map of the Moselle for his journey.

 Turner stepped onto the Continent at the beginning of August in
Ostend, from where he was able to make use of the new railway line to
Brussels. His journey to Liège took him through Belgium, a country that
had just before– in April– achieved its independence from the United Pro-

vinces of the Netherlands with the Treaty of London, following years of dispute; Turner's interest would no doubt have been sharpened by this. As in 1824, after a brief excursion to Spa he studied the Meuse from Liège to Verdun and then followed the Moselle from Metz to Koblenz. He even repeated his earlier detour to Luxembourg, where he found a changed political situation resulting from the reorganization of Belgium and Holland, which also involved the Grand Duchy. From Koblenz, as usual, he followed the Rhine as far as Cologne, then returned via Liège and Brussels.

In the course of this tour lasting barely two months Turner filled five sketchbooks with pencil studies. In addition he used loose sheets of blue paper on which he sketched in pencil and painted with watercolor and bodycolor. Among these are a few studies of the Moselle that he colored directly in the open air (illus.). In one of the watercolors, Turner conjures up a concise picture of the river landscape in a few brushstrokes, not to reproduce its specific topography but to capture the river's transitory mood; the use of the dark blue paper as a ground for the sky and water allowed him to be extremely economical and abstract. Although such works make Turner's art appear modern and pioneering to us today, we should not forget that he did not consider these private studies ready for exhibition.

The above-mentioned series of over a hundred small gouache works on blue paper which surpass even the Seine and Loire series in their painterly freedom, spontaneity and bold coloring were probably painted during the fall and winter following Turner's return home. He devoted several leaves to the popular bathing resort of Spa, southeast of Liège, including a view of the Place Royale from the "Promenade de Sept-Heures" (illus.), which reflects the elegant town's relaxed atmosphere.

In his Meuse series Turner limited himself to depicting a small number of towns, but from a wide variety of different viewpoints. He paid a great deal of attention to Luxembourg, with nearly 20 views, although he always prefered the distant view over the city. Here he found "even more pronounced than in Dinant and Namur, a dramatic juxtaposition of buildings and deep ravines that he found irresistible ..."[64] *Luxembourg from the Fetschenhof* (illus.) clearly displays this combination of nature and ramparts erected by human hand which cover the mountains with geometrical designs. The breadth of the color palette that Turner uses is remarkable, ranging from yellow ochre via red and brown tones to blue and an intense green. Most of the leaves within the series are dedicated to the Moselle, with its little villages, numerous castles and towns. The coloring here is if

96

anything almost more audacious and more visionary than elsewhere: a strong yellow, as well as pinks and reds, relate to the blue ground in a way that creates fantastic, magical moods. In the *Distant View of Cochem* (illus.) the transparent yellow, red, violet, blue and green color zones combine with the veiled sun to produce a dream-like effect.

With the completion of this series Turner's collection of material for the *Rivers of Europe* project was almost at an end. The following year he would again explore the Danube on his way to Venice, but the tours of 1841 to 1844 took him back once more to his beginnings: into the world of the Swiss Alps.

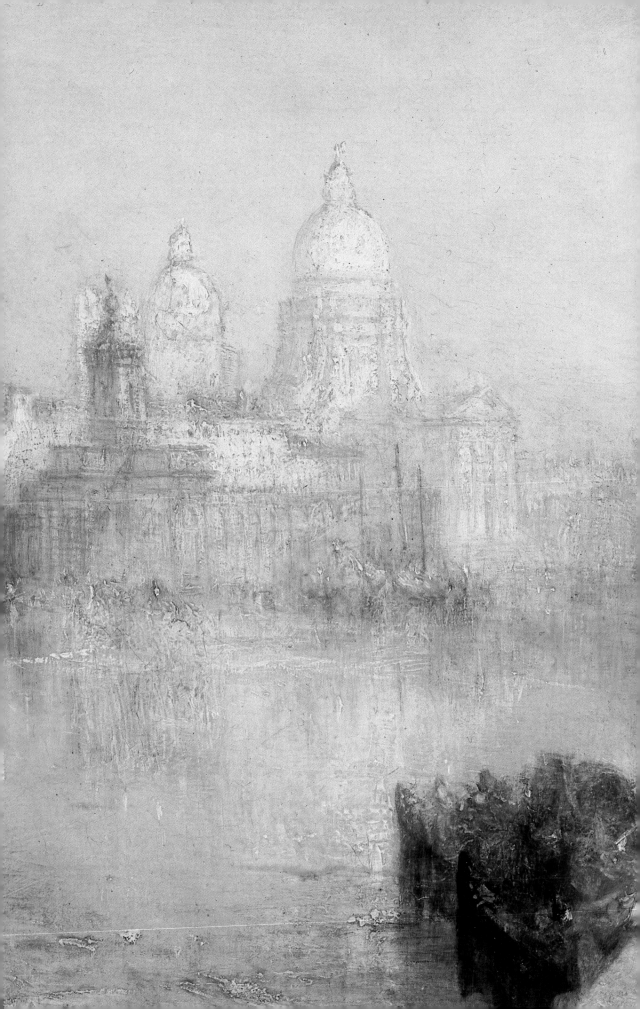

THE LAST TRIP TO VENICE OF 1840

"I stood upon a bridge, a palace and a prison on each hand"

The Venice trip of 1840, which would be Turner's last there, proved to be extraordinarily productive. One of the most important of his life, it yielded a wealth of color works of the most diverse regions as well as ideas and inspiration for later oil paintings. There is no doubt that Venice was Turner's main destination; he stayed in the city for fourteen days, longer than on his two previous visits. But before we examine the outcome of this stay we should look at his journeys there and back, which produced just as astonishing a yield.[65]

Turner no longer recorded his impressions in notebooks, he drew and painted on loose leaves of various sizes and colors – grey, blue, more rarely brown. In addition he took with him two roll sketchbooks, which he filled with colored sketches in Venice and on the return journey.

His trip began at the end of July. From Rotterdam he traveled up the Rhine as far as Lake Constance, then went from Bregenz, by way of Bolzano, to Venice. His return journey lasted almost five weeks and can

Burg Hals and the Ilz seen from the Slope, 1840

be traced by reference to his sketchbooks. First, he opted for the steamship across the Gulf of Trieste, which spared him the inconvenience of crossing the Alps. He then continued via Graz to Vienna and along the Danube to Regensburg by way of Passau. He was able to cover this stretch by steamboat too, as a regular service had been in place since 1837, but this method of travel afforded him little opportunity to sketch in detail. Nevertheless he recorded as best he could the section between Linz and Passau, which was new to him and fascinated him with its particularly wild and lonely appearance, its dark woods and spectacular bends. Passau, the 'pearl of the Danube', situated at the confluence of the Danube, Inn and Ilz, excited him so much that he resorted to color and painted the town from various different angles. From here he wandered along the Ilz until he reached Burg Hals, the ruins of the castle towering on a high, jagged cliff around which the river winds in a sharp bend (illus). Turner's romantic view is given a special charm by the hazy violet and blue tones of the horizon, which echo the blue of the river.

Regensburg viewed from the Bridge, 1840

The next stop on his journey was Regensburg, a town that English travelers did not generally take to because of its narrow streets and high, solid buildings. Turner however made any number of views of it, including some in color, usually from the distance. He was particularly fascinated by the view of the massive stone bridge, dating from the 12th century, which spans the wide river in front of the panorama of the town and its towers (illus.). Using delicate blues, browns, reds and violets on the grey paper, Turner succeeds in conveying the river's cool atmosphere on a fall evening.

From Regensburg it was only a few kilometers further to a place that Turner was one of the first travelers to pay any particular attention to: the Walhalla, then under construction on the bank of the Danube. Turner had been interested in Ludwig I's artistic endeavors and Leo von Klenze's buildings since his stay in Munich in 1833, so he considered it a matter of course to pay a visit to their latest project. Not only his liking for Classicist architecture but also the political dimension of this building, which had been conceived as a national monument in a spirit of rejection of Napo-

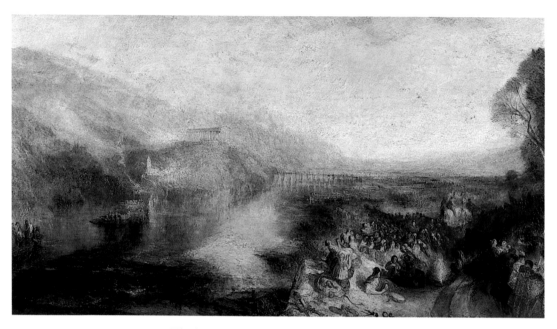

The Opening of the Walhalla, 1842, R.A. 1843

leon's striving for power, captured Turner's interest. Initially he prepared
a number of pencil sketches of the building and its picturesque situation on
a slope above the village of Donaustauf, but two years later, reading in the
London newspapers about the opening ceremonies, he decided to devote a
large-format oil painting to the subject. The *Opening of the Walhalla*, 1842
(illus.) was exhibited at the Royal Academy in 1843 with lines from Turner's
poem 'Fallacies of Hope' which start with greetings to the Bavarian king,
then refer to Napoleon's conquest of Bavaria, before ending with praise
for the upturn in the country's fortunes since the return of peace.[66] The pic-
ture shows on the left the broad river, spanned in the middle ground by a
bridge that leads up to Walhalla. The right foreground is filled with celebra-
ting crowds who merge into the background. As regards color, the composi-
tion develops from darker sections in the lower half of the picture to bright
yellow zones at the top, which make the landscape "a poetic pictorial meta-
phor on a theme of war and peace".[67] When in 1845, for the first time,
foreign artists were allowed to participate in the Royal Art Exhibition in
Munich, Turner sent this picture there, confident that it would be bought
by the person to whom it was addressed. But the picture caused a scandal.
Its content was not understood, and no one could make anything of its
painterly characteristics such as its dissolution of form or its coloring.

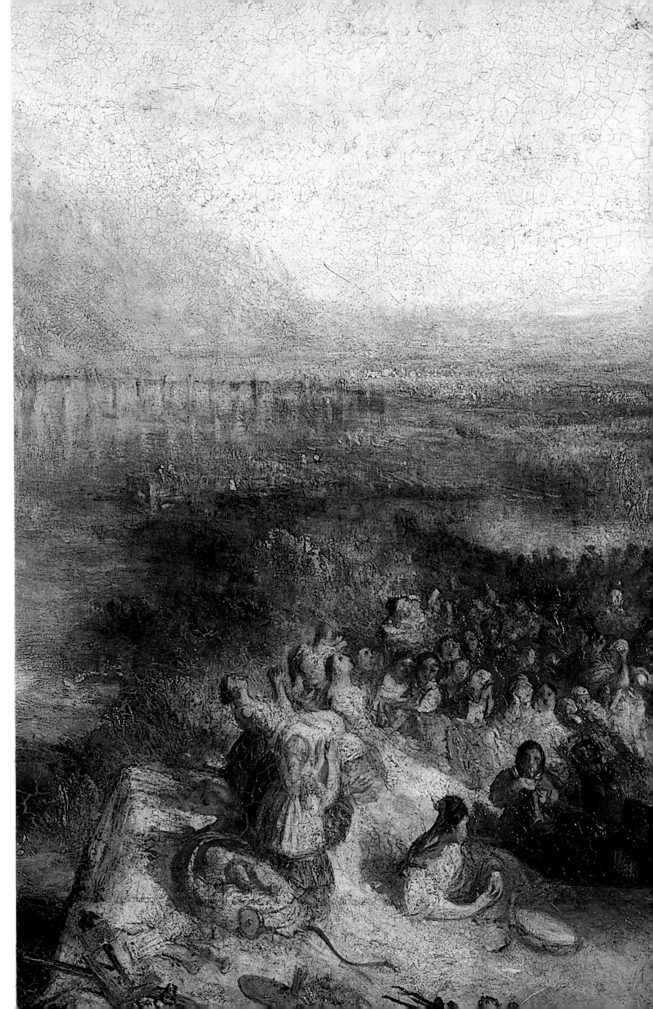

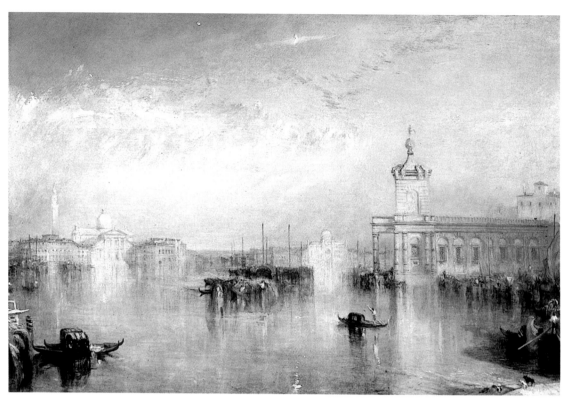

*The Dogana, San Giorgio, Citella from the Steps of the
Hotel Europa, R.A. 1842*

After exploring Regensburg and its surroundings Turner travelled on
to Nuremberg and Bamberg, from where he made a detour to Coburg.
There was a particular reason for this. In February that year Queen Victor-
ia had married the German prince Albert of Saxe-Coburg-Gotha, and the
English interest in Germany had consequently reached a high point which
was of course also reflected in literature and art. Prince Albert was repu-
ted to be a lover of art, and so Turner was on the lookout in Albert's home-
land for a subject with which he might attract the prince's attention. He
stayed in Coburg and its neighborhood for at least four days, among other
places visiting Schlofl Rosenau, Albert's birthplace. En route he prepared
pencil sketches and a quantity of sketches with color. One of the freest
and most impressionistic shows the marketplace in Coburg (illus.) with
stalls and people in the foreground, indicated only by hasty brushstrokes,
while shadowy buildings loom out of the background: on the right the
Ratshaus, on the left the Stadthaus, and in the centre the transparently
blue tower of the Moritzkirche. In combination with the grey paper the

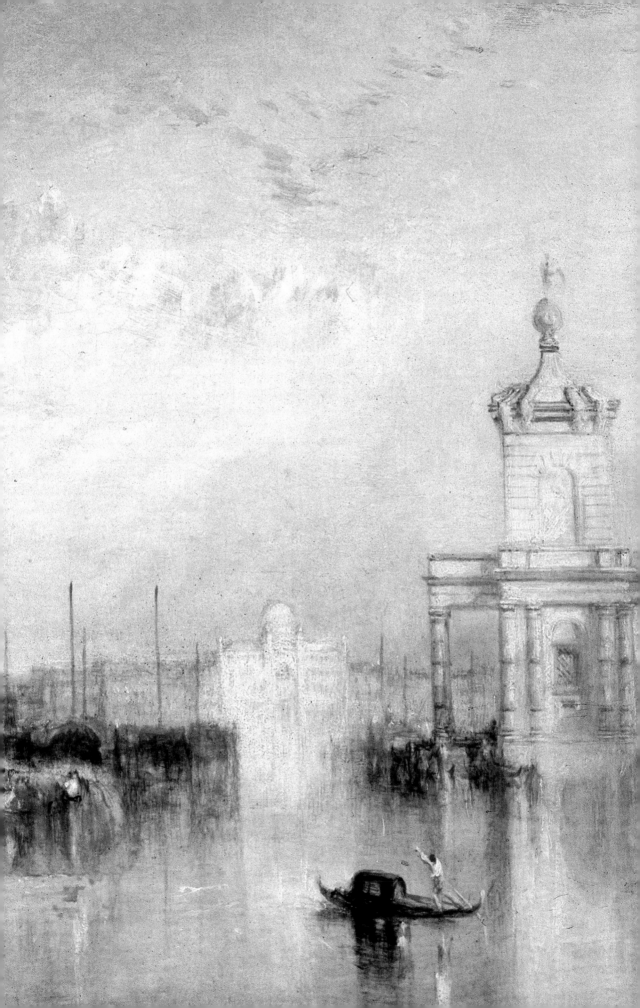

subdued, delicate colors produce a hazy, misty mood like that of an early fall morning.

Back in England Turner decided to devote an oil painting to *Schloß Rosenau* (illus.), which he showed at the Royal Academy in 1841.[68] Regardless of its connection to Prince Albert this castle held particular architectural interest for Turner. The medieval structure had been rebuilt in a Gothicizing style after Schinkel's designs between 1808 and 1817 and was thus an early example in Germany of the Neo-Gothic, which had originated in England. The landscape garden laid out at the same time, with its winding waterways, ponds, glades and specially designed architectural elements, was also based on an English model. In his topographical portrait Turner shows all these elements: in the foreground a wide expanse of water meandering into the middle ground, and trees behind which the Gothic architecture of the castle rises on the right. Turner took particular care over the reflections and the reflected light of the sun in the water. His open, relaxed manner evokes the processual nature of these phenomena. Unfortunately the picture did not meet with success, either at court or among the general public. Turner's hopes of courtly patronage were dashed again.

He had greater success in the following years with Venetian themes than with German subjects. One of the pictures that he exhibited at the Royal Academy in 1840 before setting out on his journey was a commissioned work. This may have persuaded him to go back to Venice to seek inspiration and search out new subjects on the spot. Unlike on his previous visits, this time Turner painted – either in Venice itself or shortly thereafter – a large number of watercolor studies which are of remarkable variety as regards technique and in the handling of the subject matter.[69] In contrast to the river series discussed above, Turner here rarely used bodycolor. He preferred to let the transparent watercolors shimmer against a pale ground, as befitted the atmosphere and light of the lagoon city.

Possibly he meant to present these studies to potential clients and then work them up into watercolors. This never happened, but around two dozen of the studies were bought by collectors – probably through Turner's agent Thomas Griffith – including *A Storm on the Lagoon* (illus.). In an extremely economical but effective manner, with blue and grey color zones that flow onto each other, Turner creates the impression of lashing rain that conceals the buildings delineated in a few quick penstrokes, while in

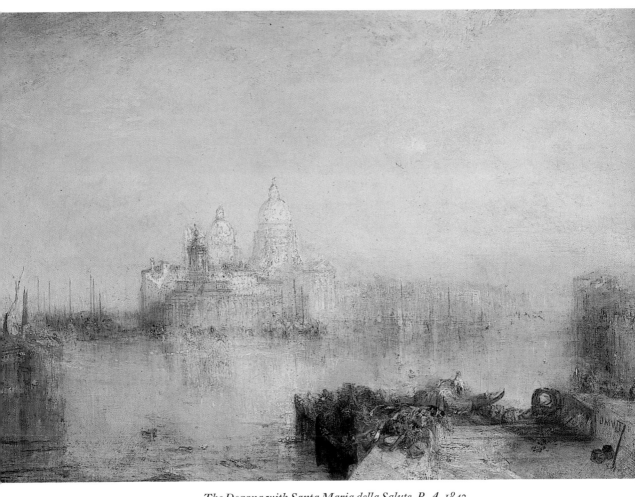

The Dogana with Santa Maria della Salute, R.A. 1843

the foreground a gondola fights its way through the agitated waters. It is the
light conditions and the consequences of the weather that interest Turner.

Various leaves are given over totally to the study of light effects and
reflections, omitting architectural or topographical details and dispensing
with pen and pencil. In other works Turner frees himself from the distant
vistas of water and architecture and plunges into the narrow world of the
canals. In one leaf (illus.) the viewer seems to be sitting in a boat, follow-
ing two gondolas that are heading towards a bridge. Sunlight falls only on
the left-hand facade; the canal itself, the boats and the right side of the
picture lie in shadow. Through the dominance of grey and blue tones,
which are offset solely by a little yellow and reddish brown, Turner cap-
tures the damp, cool atmosphere which filters through the narrow water-
ways once the sunlight has gone.

As mentioned above, Turner did not turn any of these studies into salable watercolors intended for public viewing. Perhaps he realized that their magic would be lost if he tried to render them in more detail in this medium. Instead he tried to capture the shimmering atmosphere in a series of oil paintings: a sign of his readiness to experiment with media. Although initially he had attempted to transfer the qualities of oil painting to water-colors, now he did the opposite and tried to wrest from oils the transparent delicacy and evanescent character of his studies.

As early as the spring of 1841 he presented two pictures of Venice at the Royal Academy that found buyers immediately. In 1842 he again pro-duced two Venice subjects and again both were bought during the exhibi-tion. One of these shows the wide view from the entrance of the Hotel Europa, where Turner stayed, over the water (illus.); on the right we see the Dogana, the customs-house, a reference to Venice's importance as a trading city. The second picture, *Campo Santo, Venice,* is devoted to the cemetery on the island of San Michele. In this contrasting pair of pictures Turner once more returns to the theme of former greatness and subsequent decline of a trading power and thus adds Venice to the series of great empires, such as Carthage and Rome, whose fate he illustrated in a num-ber of works. If we examine the first work, we see that the formal treat-ment matches the subject matter. The city in its late splendor seems to dis-solve and evaporate in the light. With the reflections, the reflected light and the hazy, fluid atmosphere, it seems like a vision that could vanish at any moment.

This trend is continued and taken even further in *The Dogana with Santa Maria della Salute, Venice* (illus.), exhibited in 1843. The palette has become even brighter, a yellowish white dominates the scene, and the painting technique is still more diffuse. In his book *The Stones of Venice,* which he started in 1849, Ruskin seems to put Turner's pictorial visions into words: "…[Venice] is still left for our beholding in the final period of her decline: a Ghost upon the sands of the sea, so weak – so quiet, – so be-reft of all but her loveliness, that we might well doubt, as we watched her faint reflection in the mirage of the lagoon, which was the City, and which the Shadow."[70]

Apart from the works exhibited in the 1840s, large quantities of Venice subjects remained in Turner's studio as first drafts or designs for pictures, without ever being presented to the public. Such pictures as *Venice with the Salute* (illus.), which was produced between 1840 and 1845

Venice with the Salute, ca. 1840–45

and the subject of which is almost totally dissolved in a nebulous veil of whitish yellow and blue tones, strikes the presentday viewer as unbelievably modern and abstract. Although Turner's constantly growing interest in light, air and atmosphere and his increasingly free handling of brush and palette knife made the 'lay-ins' approximate ever more closely to his finished pictures, we should not forget that he did not consider them ready for showing.

During his last years of activity Venice became Turner's most important source of motifs. This was surely not solely due to the fact that Venice was enjoying great popularity among collectors and patrons. Turner's own multifarious interests were able to find an excellent outlet in Venice. Here, his increasing preoccupation with atmospheric phenomena and light effects was able to meld with his understanding of history and his romantic world view influenced by Byron. Thus in the 1840s Venice toppled Rome from its premier position in Turner's painting and intellectual interests. But, as with Rome, Venice was for Turner not just a melancholy, pessimistic symbol of past glory but also a city which, despite its ruinous condition, still radiated beauty and vitality.

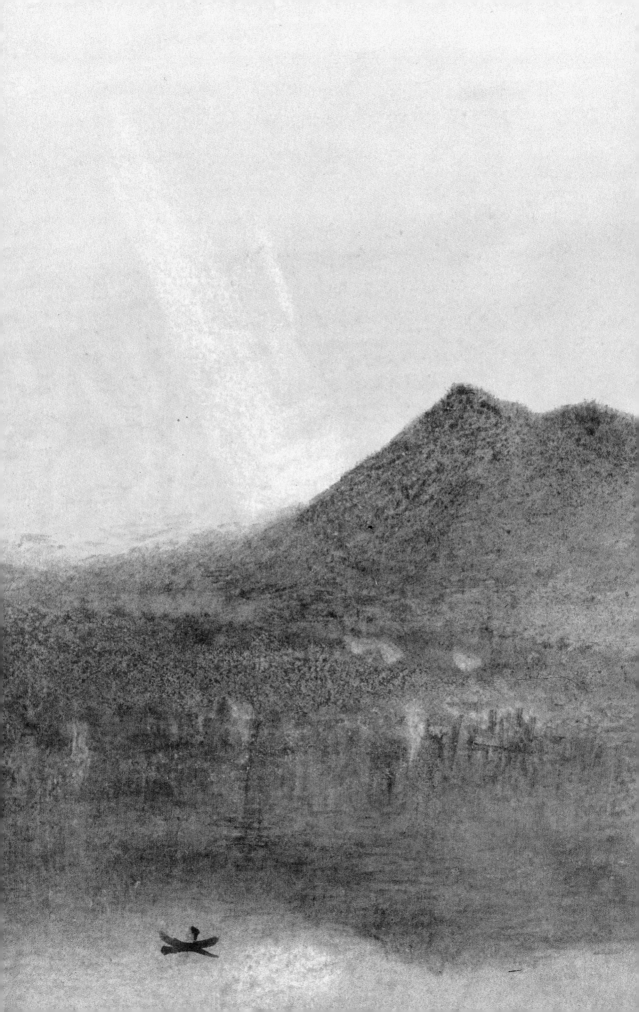

SWITZERLAND AND GERMANY, 1841 TO 1844

"Yes, atmosphere is my style"

The last journeys of his life took Turner to Switzerland every year while he continued his exploration of the German towns and rivers he visited en route. He generally traveled along the Rhine and still kept on recording even places he now knew well in pencil sketches or as colored works.

In 1841 he did a series of views of the fortress at Ehrenbreitstein, a subject he had already recorded in 1817 for his Rhine series. He had also painted it in oils in 1835; with its reference to Lord Byron's 'Childe Harold's Pilgrimage' and the allusion to the fortress's importance during the Napoleonic Wars, this painting is far more than a mere illustration of a picturesque place.[71] By contrast, in the watercolor studies of 1841 Turner is quite obviously interested in another aspect. He shows the fortress, apparently growing out of the hill, from various viewpoints at different times of day and under different light conditions: in diffuse mist with subdued colors, in the glowing, golden yellow of sunset, or in the last red of evening (illus). Keeping topographical detail to the absolute minimum, he examines the

Detail of illustration on page 116

113

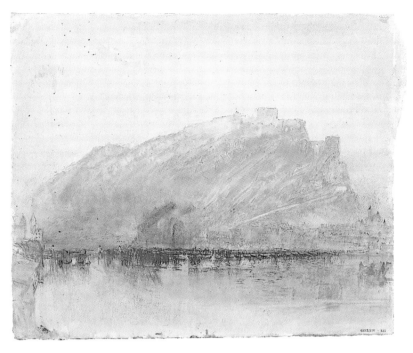

Ehrenbreitstein, 1841

effect of sundry light and color values on a chosen object, in much the same way as Monet did, years later, with Rouen Cathedral. But, unlike the Impressionists, Turner did not work from nature but from memory. He was not concerned with grasping and reproducing reality but in investigating the different subjective values of colors as well as the relationship between color and light– a thematic area that fascinated and occupied him even more after he had read Goethe's *Farbenlehre* (Theory of Colors).

Following *Schloß Rosenau and Walhalla*, around 1844/45 Turner executed his last oil painting with a German subject, inspired to do so by a journey he undertook in 1844.[72] One of the leaves (illus.) from this tour shows Heidelberg Castle from the east, a prospect that had been highly popular ever since Merian's engraving of 1618. With a minimum of effort Turner evokes a sunset by applying partially transparent yellow and red-violet washes over his pencil sketch. He used the same viewing angle for the oil painting (illus.) but – when we examine the castle, whose ruins are supplemented in an imaginary Gothic style – was obviously thinking back to another era. The picture is in fact set at the time of the Elector Palatine Friedrich V, who marked the beginning of closer relations between England and Germany with his marriage in 1613 to Princess Elizabeth, the

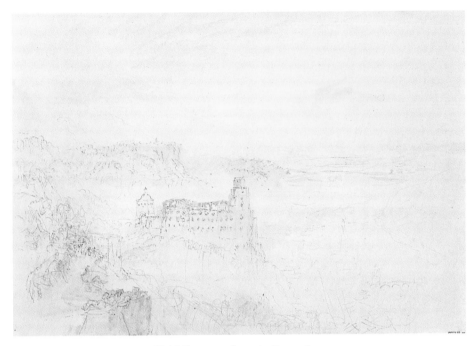

Heidelberg seen from the East, 1844

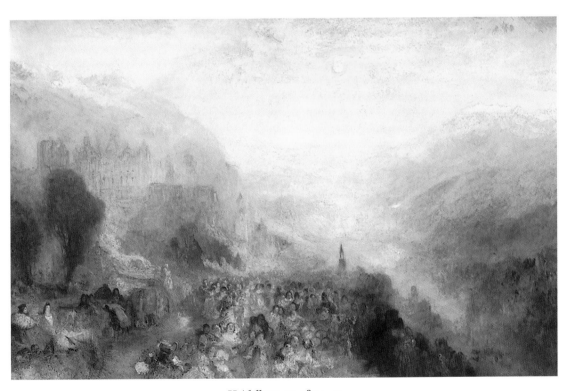

Heidelberg, ca. 1844–45

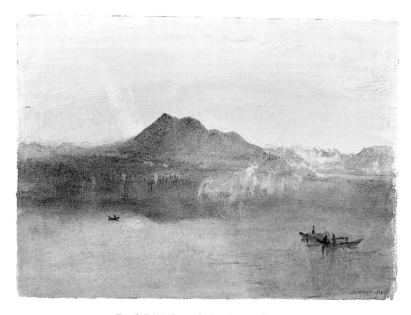

Dark Rigi: Sample Study, ca. 1841–42

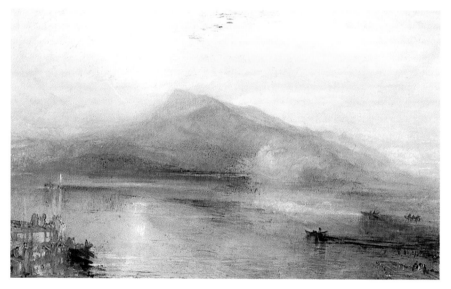

The Dark Rigi, 1842

oldest daughter of James I of England. Turner depicts the couple, whose court was renowned for its splendid festivities, in the left foreground surrounded by jubilant crowds. But, as we know, the merrymaking did not last long: Friedrich very quickly lost the electorship of the Palatinate. The famous castle was destroyed by French troops at the end of the 17th century during the Palatine War of Succession. Neglected for ages, it gained

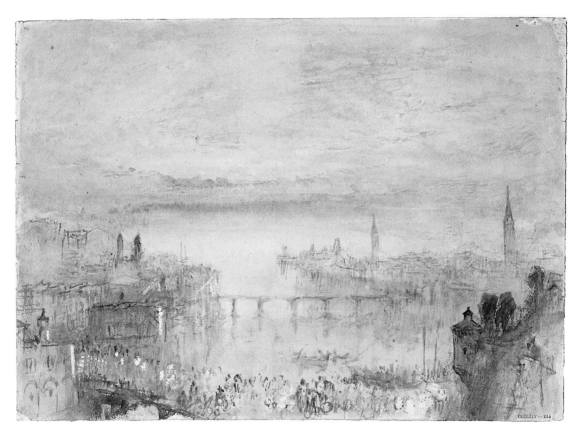

A Fête Day in Zurich: Early Morning, 1845

new importance as a ruin with national symbolic value only at the time of the Romantic movement, a fact which of course had not escaped Turner's attention: as a victim of French power politics, during the wars with Napoleon the castle had become a symbol of the German desire for unification. In view of this background the painting is closely related to the *Walhalla*, and Turner may well have regarded the two pictures as pendants, given his preference for pairs of pictures as well as his concept of history. Whereas *Heidelberg* represents the late stage of a splendid epoch already threatened by decline, *Walhalla* symbolizes the renewed rise towards war and fall.

Although Turner's interest in Germany increased in his later years, as seen in the oil paintings mentioned above, the actual target of his tours between 1841 and 1844 was Switzerland.[73] In contrast to his first journeys, he was now happy to stay in larger towns and cities such as Geneva, Lausanne, Lucerne and Zurich and also displayed a preference for the many lakes of this region.

117

A wealth of watercolors resulted from these tours. Today regarded as the high point of Turner's watercolor art, at the time they were mostly rejected on account of their misty vagueness. When Ruskin, who had finally met the artist in person in 1840, asked him about the idiosyncratic atmosphere in his late watercolors, Turner replied: "Yes, atmosphere is my style."[74] These late Swiss works differ from the early ones not only in the exceedingly evocative technique but also in his choice of subjects. From painting the Sublime, which spreads terror and horror, he had become a painter of transitory sensory impressions. From the portrayal of the noble, dark and threatening world of the mountains he had come to depict panoramic overviews in which he allocated the leading role to atmospheric phenomena.

Astonishing too was the new, systematic method he employed to sell his work. With the completion in 1839 of the series *Picturesque Views of England and Wales*, his work for such publishers of topographical series as Cooke and Heath came to an end. Nevertheless Turner did not stop producing series, the sales of which he now entrusted to his agent, Griffith. Turner prepared a series of 15 'sample studies' based on studies done en route in the winter of 1841/42 and completed four of these in order to give potential clients an idea of the finished result. Although he did not attract a new clientele and the demand was not overwhelming, he repeated this procedure in 1843 and 1845.

One of Turner's favourite subjects was Mount Rigi, on Lake Lucerne. From his hotel directly beside the lake Turner did a series of drawings of the view over the northern branch of the lake towards the mountains on the other side. In much the same way as he had experimented at Ehrenbreitstein a short time before, he depicted the mountain at different times of day. The *Red Rigi* sample study shows it at sunset. *Dark Rigi* (illus.), on the other hand, shows the mountain "in the dawn of a lovely summer's morning; a fragment of fantastic mist hanging between us and the hill", as Ruskin wrote.[75] Rigi, rendered in blue-violet tones, is reflected greeny-blue in the water, while the sky shimmers in transparent yellow. It is exciting to see how Turner converted his sample studies into finished watercolors (illus.). Although the main characteristics of the landscape are unchanged in the final work, the atmosphere, light, coloring and space are developed further in an extraordinarily subtle differentiation. Figures and boats are added to provide visual references for space and distance. Reflections, light and vapour are emphasized even more, without however

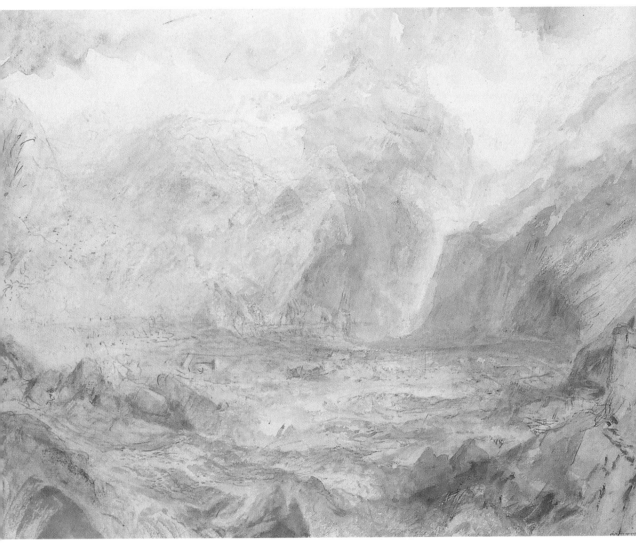

The Pass of St Gothard, near Faido:
Sample Study, ca. 1842–43

impairing the charm of the transitory which is already present to a high
degree in the studies.

Turner refers not only to nature in his watercolors but also to towns
and cities such as Geneva, Lausanne, Lucerne and Zurich. Among the last
series of sample studies dating from 1845 is an early-morning view of Zu-
rich on a festival day (illus.) Here Turner combines specifics of the topo-
graphy with compositional schemes that he continually re-uses and varies
in other contexts, both in watercolors and in oils. In this manner he sub-
jects reality to a selective process in accordance with his own preferences.

We have already seen in connection with the early Swiss works that Turner not only selects and arranges – in other words, gives certain viewpoints and details preference over others – but also exaggerates. In his late Swiss pictures, too, he makes free with the natural model. When in 1845, during a trip to Switzerland, Ruskin went to the Faido Ravine near the St Gotthard, he was able to test the difference between the reality and Turner's version (illus.). In *Modern Painters* he uses this subject to analyze Turner's handling of topography: "… the whole place is altered in scale, and brought up to the general majesty of the higher forms of the Alps".[76] Ruskin finally concludes that the aim of the great, inventive landscape painter is to grasp and reproduce not the image of a place but its spirit: "Any topographical delineation of the facts, therefore, must be wholly incapable of arousing in the mind of the beholder those sensations which would be caused by the facts themselves, seen in their natural relations to others. And the aim of the great inventive landscape painter must be to give the far higher and deeper truth of mental vision rather than that of the physical facts."[77]

With this Ruskin was defending Turner against the frequently expressed objection to his "indistinctiveness". Failing to appreciate his artistic intentions, Turner's contemporaries often applied nothing but the measure of fidelity to the truth in assessing his works.

It is not easy to define Turner's artistic aspirations in view of his great variety of interests and the range of his subject matter. Historical and political interests, literary and mythological allusions, conflict with the traditions of painting, enthusiasm for scientific advances and new technological achievements, reverence for nature and its myriad atmospheric phenomena, and – not least – sheer pleasure in traveling, in getting to know new regions, are the decisive factors that stamp Turner's artistic universe. Nor should we forget his businesslike sense for what the public wanted; thus a great part of the material collected on his tours remained unused because he saw no demand for certain subjects.

Turner owed a great deal to his journeys. His achievements in the field of the topographical travel picture were based on his ability – described above by Ruskin – not to depict, but to create visual associations. Again, the dynamic sense of movement he introduced into the traditionally static view is based not least on his personal experiences as a traveler. And he would certainly not have become the "discover of the weather",[78] the painter of atmosphere and light that he was, if he had not continually exposed himself to nature and its phenomena in the course of his travels.

Notes

1 Quote after Heinrich Heine, Reisebilder, Part 3, "Reise von München nach Genua", Frankfurt am Main 1982, p. 300 f.

2 Goethe, Faust, Part 2, Act Two; from the translation by Sir Theodore Martin, ed. W.H. Bruford, London 1954.

3 On Turner's life and work in general, see Andrew Wilton, The Life and Work of J.M.W. Turner, Fribourg 1979; idem., Turner in His Time, London, 1987; Michael Lloyd (ed.), exh. cat. Turner, Canberra 1996; David B. Brown and Klaus A. Schröder (eds.), exh. cat. J.M.W. Turner, Vienna, Munich 1997; see also Martin Butlin and Evelyn Joll, The Paintings of J.M.W. Turner, 2 vols, New Haven and London, 1977.

4 See John Gage, "'Sind Briten Hier?' – Britische Künstler in Europa im 19. Jahrhundert," in exh. cat. Zwei Jahrhunderte englische Malerei, Munich 1980, pp. 297–424.

5 Particular mention should be made of the studies carried out by Cecilia Powell, specific reference to which is made under the individual entries below.

6 On Byron, see, for example, Lesley Alexis Marchand, Byron: A Portrait, London 1971.

7 On Turner's relationship to Byron, see David B. Brown, Turner and Byron, London 1992.

8 For the tradition of topography and watercolor painting in England, cf. Andrew Wilton and Anne Lyles, The Great Age of British Watercolours 1750–1880, London and Munich 1993.

9 Cf. Oskar Bätschmann, Entfernung der Natur, Landschaftsmalerei 1750–1920, Cologne p. 45 f, and Attilio Brilli, Als Reisen eine Kunst war – Vom Beginn des modernen Tourismus: Die "Grand Tour," Berlin 1997, p. 54 f.

10 Cf. Gustl Früh-Jenner, "Die Entwicklung der englischen Aquarellmalerei im Spannungsfeld von 'Topographischer Ansicht' und 'Historischer Landschaft,'" in exh. cat. Im Bilde reisen – Moselansichten von William Turner bis August Sander, Trier 1996, pp. 25-29; also Richard Hüttel, "Im Bilde reisen – Engländer an der Mosel," in ibid., pp. 11–14.

11 After Andrew Wilton, William Turner – Reisebilder, Munich 1982, p. 15 f.

12 John Gage, Turner: Rain, Steam and Speed, London 1972, p. 38 f.

13 Quoted after Andrea Winklbauer, "Sturm, Dampf und Licht, Über Turners Landschaftswahrnehmung," in exh. cat. Turner, Munich 1997, p. 95.

14 Ibid.

15 Wolfgang Häusler, "Fallacies of Hope. Turners Kunst und die Revolutionen seiner Epoche," in exh. cat. Turner, Munich 1997, p. 82 f.; Oskar Bätschmann, op. cit., p. 99 ff.

16 Regarding the journey to Switzerland see in particular David Hill, Turner in the Alps, London 1992; also John Russell and Andrew Wilton, Turner in Switzerland, Zurich 1976.

17 Wilton, Turner in his Time, 1987, p. 62.

18 Cf. Brown, Turner and Byron, 1992.

19 Canto III, 46, from Lord George Byron, 'Childe Harold's Pilgrimage,' in The Complete Poetical Works, ed. J.J. McGann, London 1980–81.

20 Ibid., Canto III, 28.

21 On the 'Rhine picture' see Richard W. Gasen and Bernhard Holeczek (eds.) exh. cat. Mythos Rhein, Ludwigshafen am Rhein 1992; Horst-Johs Tümmers, Rheinromantik und Reisen Rhein, Cologne 1968.

22 Tümmers, ibid., p. 42 f.

23 Regarding Turner's journey, see in particular Cecilia Powell, Turner's Rivers of Europe: The Rhine, Meuse and Mosel, London 1991, pp. 11–36; idem, exh. cat. William Turner in Deutschland, Mannheim 1995, pp. 25–34 (also published as Turner in Germany, London 1995); Karl Heinz Stader, William Turner und der Rhein, Bonn, 1981; and Fred G.H. Bachrach, Turner's Holland, London 1994.

24 Byron, 'Childe Harold's Pilgrimage,' op.cit., Canto III, 18.

25 For this tour see particularly Cecilia Powell, Turner in the South: Rome, Naples, Florence, New Haven and London 1987.

26 After exh. cat. Turner, Munich 1997, p. 195.

27 Regarding Turner's stay in Venice see Lindsay Stainton, Turner's Venice, London 1985.

28 Quoted after Gottfried Riemann (ed.), Karl Friedrich Schinkel, Reisen nach Italien, Berlin 1988, p. 45.

29 Byron, 'Childe Harold's Pilgrimage,' op.cit., Canto IV, 1.

30 Wilton, Turner in his Time, 1987, p. 122.

31 Regarding Turner's visits to France see Nicholas Alfrey (ed.), exh. cat. Turner en France: Aquarelles, Peintures, Dessins, Gravures, Carnets de Croquis, Paris 1981.

32 On the theme of British artists in France see John Gage, "Sind Briten hier?," op. cit., pp. 308–48.

33 See Turner, Les Fleuves de France, intro. by Eric Shanes, Paris, 1990.

34 Quote after Wilton, Turner in his Time, 1987, p. 156.

35 After Monika Wagner, "Bilder für bequeme Körper. Zur Medialisierung der Reise im 19. Jahrhundert," in exh. cat. Im Bilde reisen, 1996, p. 20.

36 See Monika Wagner, "Ansichten ohne Ende – oder das Ende der Ansicht? Wahrnehmungsumbrüche im Reisebild um 1830," in Hermann Bausinger (ed.), Reisekultur, Von der Pilgerfahrt zum modernen Tourismus, Munich 1991, pp. 326–35.

37 Ibid., p. 333.

38 Wilton, Life and Work, 1979, p. 281.

39 Regarding this journey see Powell, Rivers of Europe, 1991, pp. 36-45; idem, exh. cat. Turner in Deuatschland, 1995, pp. 37–42.

40 For the Moselle see exh. cat. Im Bilde reisen, 1996.

41 Ibid., p. 11.

42 Ibid., p. 35.

43 See Bachrach, op. cit.

44 Powell, Rivers of Europe, 1991, p. 44f.

45 See exh. cat. Turner, Munich 1997, p. 302, and Bachrach, op. cit., p. 50f.

46 Powell, Turner in the South, 1987.

47 Wilton, Turner in his Time, 1987, p. 156.

48 Ibid.

49 Ibid., p. 158.

50 See David B. Brown, "William Turner– Leben und Werk," in exh. cat. Turner, Munich 1997, p. 38.

51 Wilton, Life and Work, 1979, p. 279.

52 On the journey and its results see Stainton, op. cit.

53 After Gage, op. cit., p. 301.

54 Walter Thornbury, The Life of J.M.W. Turner, R.A., London, 1897, p. 105.55. Powell, exh. cat. Turner in Deutschland, 1995, pp. 45–55.

56 Quote after exh. cat. Mit dem Auge des Touristen, Tübingen 1981, p. 57.

57 Ibid., p. 58.

58 After Heinz Ohff, William Turner, Die Entdeckung des Wetters, Munich 1987, p. 110.

59 Wilton, Life and Work, 1979, p. 284.

60 Powell, exh.cat. Turner in Deutschland, 1995, pp. 57–73.

61 Powell, ibid., p. 70.

62 Russell and Wilton, Turner in Switzerland, 1976.

63 Powell, Rivers of Europe, 1991, pp. 45–54; idem, Turner in Deutschland, 1995, pp. 75-79.

64 Wilton, Reisbilder, 1982, p. 57.

65 Powell, Turner in Deutschland, 1995, pp. 81–89.

66 See Pia Müller-Tamm, in Powell, Turner in Deutschland, 1995, p.107–113.

67 Ibid., p. 110.

68 Müller-Tam, ibid., pp. 121–126.

69 Stainton, Turner's Venice, 1985.

70 John Ruskin, The Stones of Venice, ed. Jan Morris, London 1981, p. 33.

71 Müller-Tam, op. cit., pp. 101–105.

72 Powell, Turner in Deutschland, 1995, pp. 91–95; Müller-Tam, ibid., pp. 115–119.

73 See in particular Ian Warrell, Through Switzerland with Turner, London 1995: Irena Zdanowicz, "The Late Swiss Watercolours", in exh. cat. Turner, Canberra 1996, pp. 128–143; also Russell and Wilton, Turner in Switzerland, 1976.

74 Quote after exh. cat. Turner, Munich 1997, p. 339.

75 Russell and Wilton, op. cit., p. 89.

76 Russell and Wilton, op. cit., p. 110.

77 John Ruskin, Modern Painters, vol. 4, London, 1856, p. 35, in The Works of John Ruskin, ed. E.T. Cooke and Alexander Wedderburn, London 1903-1912, vol. 6.

78 Ohff, op.cit. p. 132.

BIOGRAPHY

1775 Joseph Mallord William Turner
 born in London on April 23, the
 son of a barber and wig-maker.

1786 Colored Henry Boswell's "Pictu-
 esque Views of the Antiquities of
 England and Wales", the first se-
 ries of topographical engravings.

1789 Employed as a draftsman in stu-
 dios of sundry architects, incl.
 Thomas Malton, whom Turner
 called his actual teacher. Then and
 in subsequent years undertakes
 coloring and drawing commissions
 for Sir John Soane, Thomas Hard-
 wick and William Porden, the
 art dealer and publisher Paul Col-
 naghi, and the engraver John
 Raphael Smith.
 On December 12, Turner ad-
 mitted as a student of the Royal
 Academy, London.

1790 His first watercolor is exhibited at
 the Royal Academy.

Charles Turner,
A Sweet Temperament, ca. 1795, pencil,
The British Museum, London

1791 Visit to a friend of his father in
 Bristol, ketching in the Avon
 Gorge near Clifton, visits to Bath
 and Malmesbury.

1792 Starts work in the live studies class
 at the Royal Academy. In summer,
 another visit to Bristol, and
 his first sketching tour to South
 Wales.

1793 In the summer, travels to Here-
 ford, Great Malvern, Worcester,
 Tewkesbury and Tintern, in the
 fall to Kent and Sussex. Makes the
 acquaintance of Doctor Thomas
 Monro (1759–1833), in whose
 'Academy' – together with
 Thomas Girtin (1775–1802) – he
 copies watercolors by such artists
 as John Robert Cozens.

1794 Summer trip through the Midlands
 and to North Wales.

J.M.W. Turner, Self-portrait, 1791,
watercolor enhanced with white, 9.5 x 7 cm,
National Portrait Gallery, London

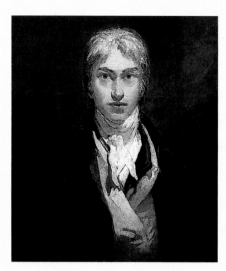

J.M.W. Turner, Self-portrait,
ca. 1799, oil on canvas, 74.3 x 58.5 cm,
Tate Gallery, London

1795 Tour in South Wales and journey
to the Isle of Wight in connection
with a commission for topographi-
cal landscape prints. Receives a
commission from Sir Richard Colt
Hoare of Stourhead to produce a
series of drawings of Salisbury
Cathedral and other buildings of
that city.

Ge-
orge Dancer, Portrait of Turner
aged 24 years, drawn by George Dancer
in March 1800 in memory of Turner's
selection as an Associate of the R.A. the
previous December, pencil, 1800, R.A.

1796 First oil painting exhibited at the
Royal Academy.

1797 In the summer, first tour to the
North of England (Yorkshire,
coast of Northumberland, valley
of the Tweed with Castle Norham,
and the Lake District).

1798 New ruling at the Academy permits
picture titles to be supplemented
in the catalog by literary quotes,
which Turner does all his life. Tour
to Malmesbury, Bristol, South and
North Wales.

1799 Turns down Lord Elgin's invita-
tion to go to Athens as topographi-
cal draftsman. Stays with William
Beckford at his country seat,
Fonthill. In the fall, visit to
Lancashire and North Wales. In
November is elected an associate
member of the Royal Academy.

1801 Summer journey to Scotland.

1802 First journey to the Continent
through France and Switzerland.
Becomes a full member of the
Royal Academy on February 12.

1804 Own gallery opened at 64 Harley
Street, where he had lived since
1799. His mother dies, mentally
disturbed.

1806 Turner rents a house beside the
Thames in Hammersmith and
lives there until 1811. The idea is
born for *Liber studiorum*, the first
volume being published in 1807,
the last in 1819.

1807 Turner elected Professor of Per-
spective (until 1838).

1808 Probably in this year first stayed
with Walter Fawkes at Farnley
Hall, which he then visited almost
annually until Fawkes' death in
1825.

1809 Sarah Danby, the mother of Tur-
ner's two daughters, moved in
with him. Turner's first stay with
Lord Egrement at Petworth; from
1831 the visits become more
frequent until Lord Egrement's
death in 1837.

1811 Turner delivers his first lecture on
perspective. In the summer, travels
to Dorset, Devon and Cornwall in

T. Cooley, Sketch of Turner during a lecture at the R.A., ca. 1812, pencil, National Portrait Gallery, London

connection with a commission from Wiliam Bernard Cooke for designs for "Picturesque Views on the Southern Coast of England" (1814–26).

1812 New gallery opened in Queen Anne Street, where he had lived since 1810.

After 1813 (until around 1825, when he moved back to Queen Anne Street) living in Sandycombe Lodge, Twickenham, a house that he designed himself. In the summer a second trip to Devon.

1816 Visits to Yorkshire and Lancashire.

1817 Tour to Waterloo and the Rhine.

Charles Turner, J.M.W. Turner, National Portrait Gallery, London, cat.no. 1182

1818 Provides watercolors for James Hakewill's *Picturesque Tour of Italy* (1818–20). In the fall, a trip to Scotland to collect material for Sir Walter Scott's *The Provincial Antiquities of Scotland*.

1818/19 Begins to convert and expand his gallery at Queen Anne Street; opened in 1822.

1819 First journey to Italy from August until January 1820.

1821 In September, journey to Paris, Rouen and Dieppe.

1822 The Cooke brothers exhibit Turner's watercolors for topographical series. Journey to Scotland,

J. T. Smith (1766–1835), J.M.W. Turner in the Print Room of the British Museum, ca. 1825?, watercolor over pencil, 22.2 x 18.2 cm, British Museum, London

where he witnesses George IV's state visit to Edinburgh.

1823 Part I of "Rivers of England" appears (last part appeared in 1827).

1824 In August, first trip to the Meuse and the Moselle.

1825 Start of work on important new project, "Picturesque Views of England and Wales" for Charles Heath, the last part appearing in 1839. In August, journey to Holland and along the Rhine.

1826	Start of work on *Ports of England*, which appears until 1828. Commission for Samuel Rogers' new edition of his poem 'Italy', which is published in 1830. Meets Hugh Andrew Johnstone Munro of Novar, one of his most important patrons. Journey to Brittany and along the Loire.
1827	Stayed with the architect John Nash at East Cowes Castle, Isle of Wight.
1828	Holds his last lecture on perspective. Stays at Petworth for a series of pictures for the dining room. Work on the engraving series "Picturesque Views in Italy", which is never published. Second journey to Italy from beginning of August until February 1829.
1829	In August travels to Paris and in Normandy; makes the crossing to Guernsey.
1830	Trip to the Midlands seeking material for the "England and Wales" project.
1831	Commission to illustrate *Poetical Works* for Scott, whom he visits in Scotland in the summer. At same time busy with illustrations for Byron's works.
1832	In September, trip to Paris.

S. W. Parrott, Turner on Varnishing Day, ca. 1846, oil on wood, 25 x 22.9 cm, Sheffield City Art Galleries, Ruskin Gallery

Alfred d'Orsay, Turner at a "Conversazione", lithograph

1833	The first of three volumes of "Rivers of France" appears, devoted to the Loire. Thomas Griffith becomes his agent. In August Turner travels along the Danube to Vienna and continues to Venice.
1834	The second part of "Rivers of France" published, with 20 plates on the Seine. Rogers' *Poems* is published with 33 of Turner's vignettes. Finden's *Landscape Illustrations of the Bible* begins to appear in monthly instalments, as does the first of 22 monthly issues of Scott's *Prose Works*.

Charles Martin, Scetch of J.M.W. Turner, 1844, pencil on paper, National Portrait Gallery, London, cat.no. 1844

126

R. Doyle, Turner painting one of his pictures, from "The Almanack of the Month", June 1846, National Portrait Gallery, London

1835	Third and last volume of "Rivers of France" appears with a further 20 engravings on the Seine. Journey to Germany, Denmark and Bohemia.
1836	In the summer, sketching tour with Munro of Novar through France and into Switzerland. "Views of India", for which Turner creates seven designs, appears in this and the following year.
1837	Campbell's *Poetical Works* appears with 20 vignettes. Death of William IV, succeeded by Victoria. In the summer, Turner travels to Paris and visits Versailles. Death of Lord Egremont. Turner resigns professorship.
1838	In August, Turner in Margate.
1839	Second tour to the Meuse and Moselle. Around 1840 Turner moves into a house on Cheyne Walk, Chelsea. Relationship with Sophia Caroline Booth. Has built up considerable wealth from sale of his works, particularly from publication of his drawings as engravings.
1840	Meets John Ruskin for the first time. Travels via Bregenz to Venice and back through Austria and southern Germany.
1841	Traveling in Switzerland from July to fall.
1842	In August, journey to Switzerland.
1843	In the summer, again traveled to Switzerland.
1844	Last journey to Switzerland, explores the Nahe and Neckar valley.
1845	In September/October, last journey, incl. Dieppe and the Picardy coast. Turner's state of health worsens perceptibly.
1846	Moves back to Cheyne Walk, Chelsea, where he lives with Sophia Caroline Booth.
1847	Contact with the photographer J.J.E. Mayall.
1851	Turner died on December 19 at his cottage in Chelsea. Buried at St Paul's Cathedral.

George Jones, Turner's Coffin in his Gallery in Queen Anne Street, ca. 1852, oil, Ashmolean Museum, Oxford

Patrick MacDowell, Statue of Turner in St Paul's Cathedral, London, 1852, marble

LIST OF ILLUSTRATIONS

Illustrations are listed in the order in which they appear in this volume

Front cover and frontispiece: *The Dogana, San Giorgio,*
Citella from the Steps of the Hotel Europa, *R.A. 1842*
Spine and back cover: *Juliet and Her Nurse*, *R.A. 1836*
(details, see page 85)

© 1997 by Prestel-Verlag
Munich · Berlin · London · New York 2004
(first published in hardback in 1997)

The Library of Congress Cataloguing-in-Publication data is available;
British Library Cataloguing-in-Publication Data: a catalogue record
for this book is available from the British Library;
Deutsche Bibliothek holds a record of this publication in the
Deutsche Nationalbibliografie; detailed bibliographical data
can be found under: http://dnb.ddb.de

Prestel books are available worldwide.
Please contact your nearest bookseller or one of
the following Prestel offices for information
concerning your local distributor:

Prestel Verlag
Königinstrasse 9, 80539 Munich
Tel. +49 (89) 38 17 09-0; Fax +49 (89) 38 17 09-35
Prestel Publishing Ltd.
4 Bloomsbury Place, London WC1A 2QA
Tel. +44 (020) 7323-5004; Fax +44 (020) 7636-8004
Prestel Publishing
900 Broadway, Suite 603, New York, NY 10003
Tel. +1 (212) 995-2720; Fax +1 (212) 995-2733
www.prestel.com

Translated from the German by Jenny Marsh, Dorset
Edited by Christopher Wynne
Designed by Maja Kluy, Berlin
Cover designed by Matthias Hauer
Typeface: DTL Fleischmann (Erhard Kaiser, Leipzig)
Typeset by LVD, Berlin
Originations by Spectrum, Berlin
Printed and bound by Appl, Wemding

Printed in Germany on acid-free paper
ISBN 3-7913-3211-2